‹ univers ›

< 宇 宙 >

‹ univers ›

〈 宇 宙 〉

‹ univers ›

はじめにはひとつの幼芽，特異点しか存在しない。　　サッカーボール大の限りなく熱く濃いこの原初の状態が，宇宙の膨張の出発点である。　　インフレーション宇宙が創造され，それが時空の始まりとなる。

ほんの一瞬のうちに，プラズマが膨大な量に達する。　　　　　　　　　　　　　物質が反物質（反対の電荷をもつ粒子からなる）より優位になる。

クォークがしだいに安定な構造を形成し，初期宇宙の温度は急激に低下する。

〈 宇　宙 〉

物理的特性が構成要素の基本的渦動に
秩序をもたらす……

……すべてが気違いじみた動きでしかない
ところに，構造をつくりだそうと試みながら。

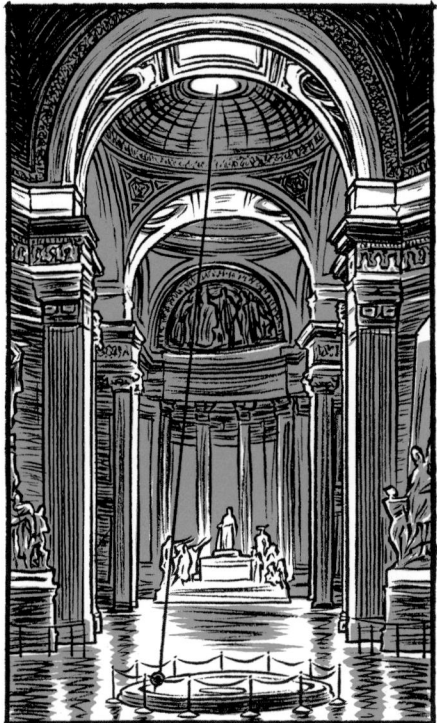

生まれかかった力の連関を，
放射が照らしにやってくる。

それぞれの衝突が新しい粒子をつくりだし，
亜原子の世界が活気づく。

電子と陽電子によって。

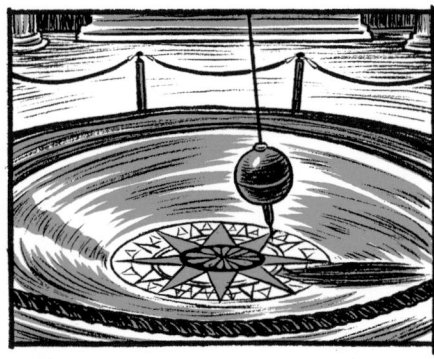

中間子とバリオン。

ハドロンとレプトン。

ミューオンとニュートリノ。

‹ univers ›

< 宇 宙 >

< univers >

このような展開がはじまって15分もたたないうちに…… ……温度が100億度にさがり，偶然的秩序の因果的連鎖が…… ……新しい時代を誕生させる。

この豊かさが粒子の流れを集合させる。

陽子と中性子が結合し，より大きな本体を形成する。

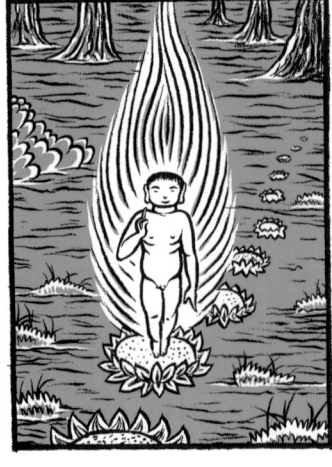 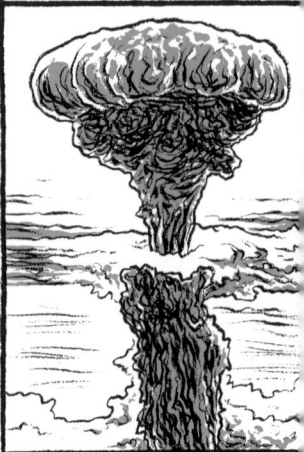

化学の見本ケースが開くと，原子の時代の始まりである。

＜ 宇 宙 ＞

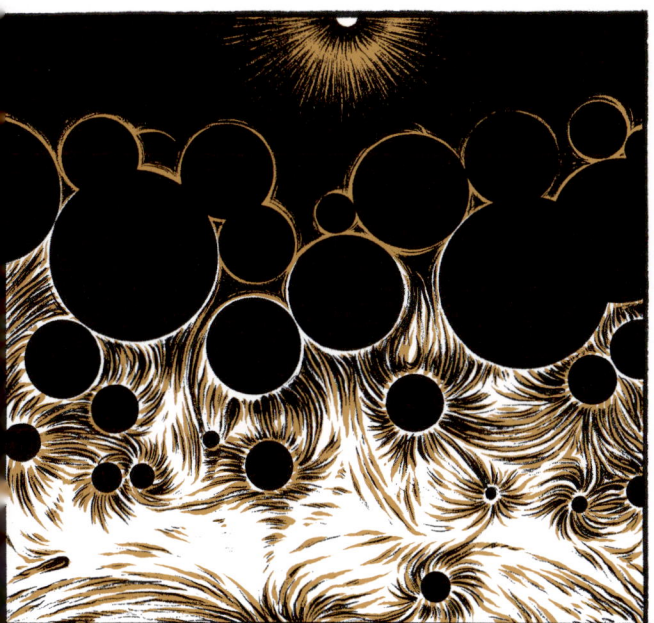

この間に，いったん下書きがなされると，諸世界の増加は途方もないドミノ効果によって果てしなく続く。

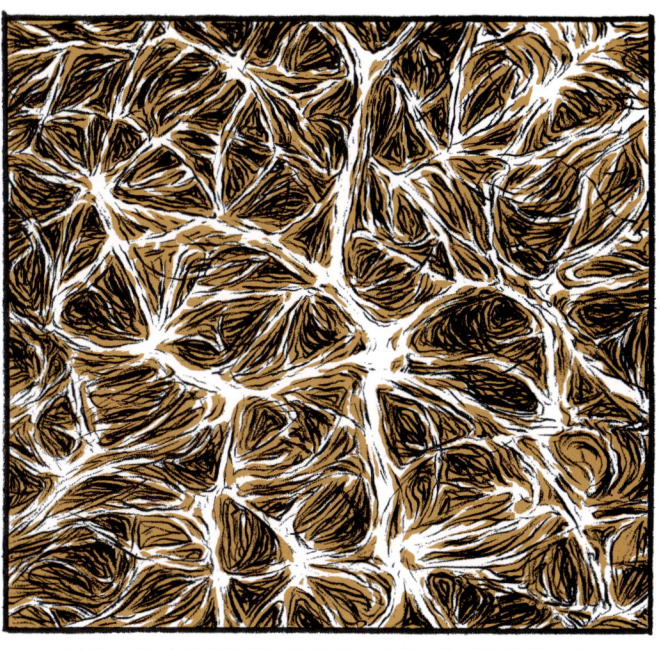

時空のサイズがふくれあがり，巨大で複雑な綿菓子を際限なくつくりだす。

混沌がこの肥沃な過程をさらに促進する。

この企てにおいては物理法則によって導かれ，

近しかったエネルギーと物質は分離する。

宇宙は冷却し続け，そして………

………闇となる。

‹ univers ›

‹ 宇　宙 ›

‹ univers ›

100万年がまたたくまに過ぎ去り，間接的な弱い放射だけが宇宙を横断する。これ以後宇宙は透明になり，その温度は原初の炎熱のあと，もはや数千度にしか上昇しない。

しかし生成する質量は新しい力をとりわけ重視する。

存在するすべての対象がたがいに引き合う普遍的な能力。

< 宇 宙 >

物理学の四つの基本的な力のひとつ，天体力学全体の基礎であり原動力である――重力。

水素やヘリウムのような軽い気体がこれ以後固有の質量をもち，集中し始める。

物質が空間の十字路に集まり，凝縮し，将来の発展の中心地となる。

しかし潜在的反応の最初の核が活動し始めるには，さらに2億8000万年が必要だろう。

< univers >

〈 宇 宙 〉

< univers >

〈 宇 宙 〉

‹ univers ›

< 宇 宙 >

‹ univers ›

〈 宇 宙 〉

‹ univers ›

原子がこれまでブラウン運動に従っていたように見えるとするなら，これ以後その相互作用は少なくとも非同質的である。

重力が物質を成り行きまかせに凝縮し……　　　　　　　　……力学的集積の崩落を引き起こす。

＜　宇　宙　＞

数百万年のあいだに，核融合反応の舞台である数百万度の中心核が形成される。水素と重水素という原始の気体の燃焼がヘリウムを生みだす。最初の恒星の誕生である。

さまざまな恒星が出現する。白色矮星，赤色超巨星，あるいは太陽に似た黄色の形態。

最初の集団，とりわけたがいに結ばれた二つの星で構成される2連星系が形成される。

< univers >

燃焼が終わると星々は死に，その融合からより重い新しい原子が誕生する。

ある種の星は膨張し，巨大な超新星に変貌し，最後には死んだ金属の塊にすぎなくなる。

質量がより大きな星はパルサーに変化する。

あるいは呑みこまれて巨大なブラックホールになる。

〈 宇宙 〉

‹ univers ›

最初の星が原始銀河を形成する……

……それが20億年から60億年かけて消滅する。

静かに回転するさまざまな球状の形態のほかに……

……しだいに複雑な系が構成される。

〈 宇 宙 〉

二重銀河

棒渦巻銀河

渦巻銀河

銀河群

見えない中心の動力に操られているかのように，きわめて質量の大きなブラックホールによって操作され，常に動いている。

‹ univers ›

〈 宇 宙 〉

‹ univers ›

中程度の大きさのそのうちのひとつが，30ほどの他の系とともに，局部銀河群と呼ばれるものの一員になる。

< 宇 宙 >

天の川銀河

‹ univers ›

おごそかな動きで自転する，数千億個の星で構成された光の円盤。

〈 宇 宙 〉

60億年を少し過ぎたころ，天の川銀河の周辺部で，軽い気体と星の塵でできた冷たい雲が分離する
——輝きを失ったり爆発したりして死んだ，第一世代の星の残骸。

原始太陽の霧が凝縮する。　　　　　　　核融合が始まる。　　　　　　　新しい星が燃えあがる。

< univers >

太陽

〈 宇 宙 〉

‹ univers ›

続く数百万年のうちに安定する。

しかし表面では擾乱がたえまなく続いている。

〈 宇 宙 〉

ガスの嵐がその覆いを引き裂き，黒点がその輝きを乱し，対流がそれを磁化する。

< univers >

この溶鉱炉の中心では，温度は摂氏1500万度に達する。表面ではおよそ6000度である。

この原始太陽は公転する分厚い雲にまだ囲まれているが，やがてその雲は凝縮して塵の環となる。

〈 宇 宙 〉

しかし小さな乱流が蓄積する。

そして稠密(ちゅうみつ)な物体が誕生する。

‹ univers ›

〈 宇 宙 〉

‹ univers ›

〈 宇宙 〉

‹ univers ›

〈 宇 宙 〉

‹ univers ›

たえまなく相互作用するさまざまな構成要素によって，太陽系がしだいに分化する。

最初の氷塊が形成される。

彗星と小惑星。

そして最後に九つの惑星。

水星や金星のように，ある種の惑星はむしろ慎ましい大きさの熱球のままにとどまる。

土星や木星のように，他の惑星は重くて冷たいガス状の巨星になる。

ひとつの惑星だけが，致死的な両極端のあいだで均衡をとることに成功する。

< 宇 宙 >

地球

‹ univers ›

0

はじめに特異点が存在する。

サッカーボール大の限りなく熱く濃いこの原初の状態が，宇宙の膨張の出発点である。

1　宇宙

インフレーション宇宙が創造され，熱く不透明なプラズマが，太陽の10億倍の10兆倍のエネルギーをもって，爆発の結果であるかのように広がる。これが時空の始まりである。

10^{-43}秒　プランク時代。物質と反物質の均衡が，物質に有利になるように破れる。放射の温度は急激に低下する。

10^{-39}秒　クォークと反クォークに支配された電弱時代，統一時代。

10^{-11}秒　弱い力が電磁力から分離する。

10^{-5}秒　クォーク時代，ハドロンとレプトンの時期。クォークは陽子，中性子，中間子，バリオンに変化し，ガンマ線は電子・陽電子対を形成し，温度はいまや1000億度に上昇する。

0,01秒　原子形成の時代。陽子と中性子が集合して水素，ヘリウム，リチウム，重水素の核となる。宇宙の温度は10億度に低下する。

3分　放射の時代のあいだ，エネルギーと物質は緊密に結ばれている。

30万年　エネルギーと物質が分離する。光学的に濃密だった宇宙は宇宙背景放射に対して透明になる。温度は3000度にまで低下する。軽い核が緩慢な電子を引きつけ，初期には水素とヘリウムの原子だけを，1ヘリウム原子に対し4水素原子の割合で形成する。宇宙はすでに10^{20}km（およそ1000万光年）の広がりに達した。

100万年　暗黒時代。宇宙の拡大にともない，背景放射の温度は宇宙が暗黒に見えるように低下した。

2億8000万年　大規模構造形成の時代。物質の塊がクエーサー，恒星，星団を形成し，とくに恒星の中心でヘリウムが燃焼するときに，重い核──炭素，酸素，珪素，マグネシウム，鉄──の合成が生じる。質量の大きな星は爆発し，超新星になり，それがより重い元素を次の世代の星々に遺贈する。

7億年　最初の銀河がつくられ始める。もとが円盤の形であった銀河は，一部が楕円形に変化する。さまざまな星の群が誕生し発達する。こうして褐色矮星，太陽に似た星，白色巨星，青色超巨星が（さらには白色矮星，赤色超巨星，パルサー，連星系なども）見られるようになる。それらはすべて最後には死に，超新星，金属塊，あるいはブラックホールに変化する。

13億年　天の川銀河が，原初のガスと死んだ星の残骸でできた雲から形成される。その後それは他の星の集団と衝突し続ける。次の世代の星の周囲で，惑星をもった最初の太陽系が出現する。

70億年　暗黒エネルギーが宇宙の膨張を加速し始める。

87億年　天の川銀河と他の銀河が衝突したとき，われわれの太陽系が誕生する。暗い雲が収縮して原始太陽を形成し，外層から分離する。外層から生じた塵の環が冷却し，氷と岩の塊，次いで小惑星の環と雲，および九つの惑星──地球やガス状巨星のような──が出現する。それらはときに衛星や大気をもっている。

92億年　この雲の中心の温度が100万度に達し──太陽が燃え始める。

‹ 隱生累代 ›
冥王代

‹ cryptozoïque ›

凝縮が終わると，若き地球は冷却し始める。周囲の塵の円盤の残骸に由来する，絶えざる宇宙からの爆撃と，放射性元素の崩壊が，この過程を非常に複雑にする。

〈 隐 生 累 代 〉

‹ cryptozoïque ›

存在し始めた頃，地球は火星大の原始惑星との衝突をかろうじて免れる。

< 隠 生 累 代 >

その惑星がかすめたときに原始地球からはぎとった，液状の岩石と鉱石の巨大な尾が安定し，物質の環を形成する。それが収縮して新しい天体の月を形成するまでになる。

‹ cryptozoïque ›

< 隠 生 累 代 >

これ以後の地球はよろめく衛星を伴侶としてもつ。

光と重力に関しては太陽のライバル。

6億年後に月の内部は凝固する。

かき乱された地球の表面は進化し続ける。

‹ cryptozoïque ›

こんにちよりおよそ5倍速く自転する地球に対し，月はブレーキの役割を果たす。月は現在の距離の10分の1，すなわち3万km離れたところで地球の周囲をまわる。

太陽系の「原動力」はこれからは完璧である。

太陽系はさまざまな依存反目にいろどられる。

〈 隱 生 累 代 〉

PYROPHYLACIORUM

‹ cryptozoïque ›

〈 隱 生 累 代 〉

‹ cryptozoïque ›

軽い珪酸塩が最初の地殻を形成するが，それはまだ非常にもろく，内側と外側でたえず引き裂かれる。

< 隠 生 累 代 >

火山の攪拌槽(かくはんそう)が深部のマグマをたえまなく上昇させる。

しかしマグマは一時的な表皮しか形成せず，やがてもとの場所に戻る。

‹ cryptozoïque ›

地表の安定性はたえず厳しい試練に見舞われる。非常にゆっくりとしか冷却・固化しない。

放射性崩壊の過程が内部の沸騰を維持している。　　　　　　　　内部を構成する物質が分化し始める。

＜　隠　生　累　代　＞

やがて自転力が液状の鉄の外核を，非常に密な固体の鉄でできた内核のまわりに回転させる。

この巨大な発電機が磁場をつくりだす……

……宇宙線と太陽面爆発に対する防御の盾。

それでも隕石に対しては無力である。

月だけがときどき地球に対し盾の役割を果たす。

‹ cryptozoïque ›

地球の年齢はすでにおよそ4億歳となったが，とくに生命に対しては相変わらず敵対的である。

自転は非常に速いので，
1日は5時間しか続かない。

ずっと以前に原始大気の水素は消滅した。

地球は強烈な宇宙線と
さまざまな衝撃の標的である。

温度の途方もない変動が
巨大な嵐を引き起こす。

二酸化炭素と他の気体が混合した
新しい大気は有毒である。

地殻から漏れる蒸気が
この温室をさらに暖める。

＜　隠　生　累　代　＞

太陽はまだすべての火を用いて輝いてはいないので，濃いガスの塊の下では熱く暗い。

しかし冷却が優位を占め，地球の温度は100度の目盛りの下にまで低下する。

大量の雲はついに重荷を捨て去ることができる。そして初めて雨が降る……

‹ cryptozoïque ›

〈 隱 生 累 代 〉

‹ cryptozoïque ›

〈 隱 生 累 代 〉

91

‹ cryptozoïque ›

土砂降りの雨が最初の窪地を満たし，急速にあふれだす。ずっと以前に凝固した溶岩の柵は，水塊の圧力のもとで破裂したり取り払われたりする。しだいに大きな水域が形成される。

〈 隠 生 累 代 〉

しかし水はまだ白熱している地殻に触れて蒸発する。原始海洋は非常にゆっくりとしか形成されない。

‹ cryptozoïque ›

数百万年たつうちに，海はそれほど高くない区域をついに覆うようになり，かつて巨大であった火山の頂上は，もはや原始海洋の上に取るに足りない群島として浮かんでいるにすぎない。

< 隠 生 累 代 >

水蒸気の大部分が雨に変わると，地表はほぼ全体が水に覆われたように見える。

あえて波浪に挑戦する，より高い地帯は別にして。　　　　　　　　まだ名前のない最初の大陸。

‹ cryptozoïque ›

これ以後自然の力のオーケストラは全員がそろい，権力闘争はすでに始まっている。

< 隠 生 累 代 >

蒸発，沈殿，侵食によって，すべてを結ぶ水循環の大メリーゴーラウンドが動きだす。

‹ cryptozoïque ›

〈 隠 生 累 代 〉

‹ cryptozoïque ›

地殻はたえず再生される——水と風は火道が地表に運んだものを粉砕する。

そして他の場所に蓄積する。　　こうして岩石が形成される。　　さまざまな種類の土壌も。

〈 隱 生 累 代 〉

‹ cryptozoïque ›

この間に対流がマントルのなかで形成され，地殻に作用し始める。

マグマが自軸を中心とした回転運動によって地殻をひっぱる。

そしてプレートテクトニクスの機構を始動させる。

これ以後はすべてが可動的である。

大陸はたがいにこすれ合い，他の場所で消滅し再生する。

< 隱 生 累 代 >

‹ cryptozoïque ›

2　冥王代

46億年前　地球の形成。当初その大きさは火星ほどである。水素とヘリウムの混合である原始大気は，やがて圏外に放出される。続く6億年のあいだに，微惑星の爆撃によって地球の直径は1万2000kmに達する。他の原始惑星との衝突をかろうじて免れたとき，大きな物質の塊が離脱し，それが地球のまわりで環を形成し，次いで固化する。こうして地球・月系が誕生する。

46億年前から42億年前　微惑星の衝突によって解放されたエネルギー，地球内部における放射性元素の崩壊，太陽放射の増大などが若き地球を暖める。液状の金属核（主として鉄，珪素, ニッケルからなる），多少とも粘性のあるマントルから分化する。地球の自転にともない，このマントルを構成する物質が核のまわりを回転し始め，このため保護的な磁場がつくられるが，内部で渦流が出現すると，やがて大陸の漂移も開始される。珪酸塩でつくられた軽い地殻は，凍結した隕石の衝撃にたえずさらされている。隕石のガス状の成分は，たえまのない火山活動がマントルの外に噴き上げる蒸気と結合し，新しい大気を形成するが，それは有毒で，水蒸気が70％を占めるほかは，主として硫化水素，メタン，アンモニア，二酸化炭素で構成されている。遊離酸素はまだ完全に不在である。地球は強烈な放射と，巨大な嵐と，強い温室効果にさらされている。

42億年前から40億年前　最初の岩石地殻の形成。それはまだもろく，さまざまな衝撃によってしばしば引き裂かれる。激しい火山活動が地表に溶岩とガスと水蒸気を運んでくる。地表の温度は100度以下に低下し，豪雨が地上を襲い，全地球的な原始海洋が形成されるとともに水圏が出現する。若い地殻は，水循環が始動したために生じた侵食にただちにさらされ，最初の堆積物が形成される。

41億年前　現在カナダで見ることができる片麻岩の堆積の形成。これは知られる限り最古の岩石である。

40億年前　水位が上昇した海洋の圧力のもとで，またマントルの運動がしだいに大きくなったため，地殻はいくつかのプレートに分裂し始める。最初の大陸が形成され，地球内部で回転するマグマの流れが，プレートテクトニクスの機構を始動させる。

39億年前　知られる限り最古の岩石の磁化は，磁場が確立していたことの結果である。

‹ 隠 生 累 代 ›
太 古 代

‹ cryptozoïque ›

続く数百万年のあいだ，地球と呼ばれるこの第3惑星の上に大したことは起こらない。

大陸プレートは漂移する。　　　　　火山は山をつくりだす。　　　　　小惑星はクレーターをうがつ。

〈 隠 生 累 代 〉

極微のレベルでは，それでも革命が準備されているが，地球に立ち寄るだけの者にそれは見えない。

‹ cryptozoïque ›

それはまず沼のなかで起きるのか……　……それとも粘土の湿った堆積のなかで起きるのか，正確にはわからない

活動的な海底火山の火道の近くか……　……それともすでに感染していた他の天体からやってくるのか。

触媒に助けられて不安定な原子が結合し，無数の複雑な分子を形成する。

< 隠 生 累 代 >

アンモニア，メタン，硫化水素などの気体の，吐き気を催させるような混合が，微小な空間に集中する。

‹ cryptozoïque ›

好ましい条件のもとで，それらの気体がのちに「有機の」と呼ばれる分子を形成する。

‹ 隠 生 累 代 ›

それがアミノ酸の出現である。

ヌクレオ塩基とヌクレオチド。

そして砂糖のような最初の糖質。

‹ cryptozoïque ›

これらの成分がたえず新しい結合をつくりだす。

その結合はさほど好ましくない環境ではすぐに壊れる。

環境の脅威はさまざまである。熱と寒気，有毒ガス，高圧，電気，あらゆる種類の致死的な放射がある。

〈 隠 生 累 代 〉

しかし巨大な実験室はけっして閉鎖されない。　　　次々に起こる近似的形態が新しい原型をつくりだす。

しだいに長い連鎖が形成される。安定した連鎖。複製が可能な連鎖。

‹ cryptozoïque ›

< 隱 生 累 代 >

‹ cryptozoïque ›

仮想の訪問者はまだそれらをまったく見ることができない。原始生命のこの質的飛躍を見るためには……

< 隠 生 累 代 >

……数億年またなければならないだろう。それでも沈黙を続ける表層の下では何かが起こっている。

‹ cryptozoïque ›

安定したRNAの連鎖が形成され，原始的な脂質膜を用いて環境に挑戦する。

その連鎖は成長し分裂する。　　　　　　物質とエネルギーを吸収する。　　　　　自身の構造を改良する。

< 隠 生 累 代 >

このような変化は自律的になる──そして地球の歴史の新しい章が始まる。

‹ cryptozoïque ›

< 隱 生 累 代 >

‹ cryptozoïque ›

〈 隱 生 累 代 〉

< cryptozoïque >

それでも繁茂した珪藻(けいそう)の群体が出現するのはずっとのちである。原始海洋にはまだ住人がいない。

しかし委ねられた大地を仮借なく洗いむしばむため、
海の総量は増大する。

堆積物としだいに多くの塩が水に溶け、
海水の重要な構成要素になる。

< 隠 生 累 代 >

原始海洋の重量が地殻のさまざまな断片を引き裂き終え，それらの漂移を加速させる。

‹ cryptozoïque ›

プレート同士は衝突したり重なったりして，巨大な山塊を形成したり地震を引き起こしたりする。

〈 隠 生 累 代 〉

それでも地球の最初の住人は発展し続け，長期間生存できるようになる。

本体は分化し，新しい要素は同化され，所与の安全は増大する。

ふたつの用心はひとつの用心にまさる——原DNAの単純な系列は接合し，二重らせん分子を形成する。

‹ cryptozoïque ›

しだいに複雑になる二重らせんは，やがて蛋白質合成を
コード化するだけではもはや満足しない。

それはすべての遺伝子形成の基盤と，その所有者にとって
申し分のない構築のプランとなる。

〈 隱 生 累 代 〉

‹ cryptozoïque ›

宇宙のなかで最も複雑な分子が登場する。ヌクレオ塩基の無数の対が，これから発達するものを決定する。

〈 隠 生 累 代 〉

当初の拘束から解放され，不断の突然変異に励まされ，原始生命は全速力で広まる。

生物はさまざまな方向へ発展する——そのうちのひとつが，地球の最初の生物界の起源となる。

‹ cryptozoïque ›

バクテリア

< 隱 生 累 代 >

‹ cryptozoïque ›

やがてバクテリアは全地球に満ちあふれる。海底ではどこでも，卵白状の群体と粘っこいカーペットが増殖する。

< 隠 生 累 代 >

これら地球の支配者が環境を大きく変化させる。化石を含む最初の地層とともに，それらは新しい種類の岩石を作りだし，そこに驚くほどの量の鉱物を貯蔵する——将来の鉱床である。

しかしその上部の大気のなかでやがて突発する大変動に比べれば，これは何ほどのことでもない。

‹ cryptozoïque ›

細胞内部で生まれた新機軸が食糧源を多様化させ、葉緑素が光を「食べられるもの」にする。

$6\ H_2O$ + $6\ CO_2$ = $C_6H_{12}O_6$ + $6\ O_2$

これが光合成の始まりであり、シアノバクテリア（藍色細菌）の重いカーペットが純酸素によって大気を「汚染する」。

< 隠生累代 >

酸素分子の一部がオゾンをつくり，宇宙線から地球を保護する覆いが形成される。

‹ cryptozoïque ›

3 太古代

39億年前 大陸の漂移がゆっくりと始まり,プレートが接触する地点で山の形成が促される。水循環が地殻に含まれる塩をますます多く海中に運び,海の塩分濃度は増加する。

38億年前 生命の基盤となる元素から,最初の複雑な有機分子が形成されると,化学進化が開始され,自己複製が可能な巨大分子が誕生する。

33億年前から30億年前 細胞に核が含まれていない最初の生物(原核生物)――古細菌とバクテリアのような――と,化石化されないがすでに光合成を利用する原始的な生命の形態が出現する。地殻の岩石のなかにストロマトライトと鉱石がはじめて堆積する。大気中の遊離酸素が豊富になり,大気上層でオゾン層が形成され始める。

27億年前から25億年前 地表を動くプレートのモザイクのような,持続的かつ完全な地殻の形成が終了する。このプレートの漂移と衝突が新しい山を形成する。最初の大陸核が海中から外にでる。

‹ 隱 生 累 代 ›
原 生 代

‹ cryptozoïque ›

生命――動的秩序，地球全体を
征服する型式。

再利用され，発展し続ける
感応性，複雑性。

< 隠 生 累 代 >

過ぎゆく時間に，そしてエントロピーの原理にも抵抗する構造。

太陽に起因する特異な現象，生物圏の驚くべきネットワークの構築。

‹ cryptozoïque ›

目に見える生物はまだ現われていない。大変動はまだ極微の段階でしか生じていない。

世界はバクテリアに支配されている──選択の自由はないが，成功するためのあらゆる機会をとらえる原始的構造……

〈 隠 生 累 代 〉

環境内の酸素濃度が急激に増大したため，地球の最初の生命の大部分は消滅する。

しかしいくつかの生物は生き残ることに成功する——適応したり，逃亡したり，他の生物の食物になったりして。

‹ cryptozoïque ›

生命をつくるために，また熱力学的平衡という不可避の瞬間を押し戻すために結合したあと，化学的成分はいまやできるだけ有利な共生のネットワークを形成しようと努める。

ある者は他の者から自分に欠けている資質を受けとる。エネルギーや食物，可動性や防御力，偽装の能力，質量，力など……

「食うか食われるか」のゲームは新しい形態をとる。　　　　　　　　　ある種の犠牲者は密航者に姿を変えるから。

< 隠 生 累 代 >

こうしてそれらは消化できない覆いによって保護され，共生という戦術を発明しながら，抵抗力をもつ種族に編成される。

それらは徐々に統合される。　　それが将来の植物の葉緑体……　　動植物のミトコンドリアである。

そのとき新しい展開が生じる──新しい型式が出現し，進化は質的飛躍をなしとげる。

‹ cryptozoïque ›

真核生物

146

< 隐 生 累 代 >

< cryptozoïque >

生物学的新機軸の連鎖は途切れない。　　　　　　　　　　　有効な触媒である性と死が登場する。

≪ 隠 生 累 代 ≫

有性生殖はたしかに生物から永遠の生を奪うが，より多くの自立を生物に与える。

‹ cryptozoïque ›

< 隠 生 累 代 >

これ以後母細胞の分裂は，生殖の際の男性と女性の配偶子の融合によって置き換えられる。

こうして生物の遺伝形質はもはや単に複写されるのではなく，再結合されたえず改良される。

‹ cryptozoïque ›

可能性は増大し，成功しなければならない
責務は切迫したものとなる。

構築のプランのたえざる再プログラム化：
変異や突然変異をつくりだす。

不完全な細胞分裂，共生的あるいは一時的な結合が，最初の多細胞生物を誕生させる。

〈 隱 生 累 代 〉

153

‹ cryptozoïque ›

多細胞の生命はさまざまな方向に進化し，三つの主要な「界」に分岐する。

光合成に賭ける植物。　　　　　　有機物を利用する菌類。　　　　　　生物を食糧とする動物。

< 隠 生 累 代 >

原生代の末には，多くの温室効果ガスがバイオマス（生物量）のなかに吸収されて気温が急激に低下する。
摂氏0度の魔法の境界が越えられ，初めて水は氷に変化する。

気候は大変動にさらされ，両極からはじまった全体的な氷期が地球のほぼ全域を凍らせる。

‹ cryptozoïque ›

それとは別に，地球の液状の核も部分的に「凍結」し，磁場が強まる。

ずっと以前に原始大陸は分裂した。　　　　　　　　新しい超大陸ロディニアがつくられる。

より大規模な変化も存在する。たとえば太陽は徐々に全能力を発揮するようになる。

< 隠 生 累 代 >

5000万年後，大部分の生物に影響を与えた最初の大量絶滅が終了する。

致死的な締めつけがついにゆるむ。凍った地球は隕石と火山活動の影響のもとで暖かくなる。

‹ cryptozoïque ›

生命は急速に再登場し，再組織される。

細胞群体と分業が死に打ち勝つ。

‹ 隠 生 累 代 ›

$sin(z)+z^2+c$
z^z+z^6+c
$sin(z)+z^2+c$
z^z+z^5+c
z^z+z^6+c
z^5+c
z^z+z^5+c'
z^3+c
$sin(z)+e^z+c$

放散虫のように，いくつかの種族は石灰質の廃物を数学的計画にしたがって同化する。

こうして最初の腕足動物が覆い構築の訓練をする。それらはよく保存された化石を構成する。

‹ cryptozoïque ›

蠕虫状の生物や，繊維質あるいは海綿質の生物が登場し，地球の生物圏ですぐに優勢になる。

< 隱 生 累 代 >

‹ cryptozoïque ›

原始的軟体動物が不要な重荷を捨て，透明な軽さに挑戦して成功を収める。

< 隠 生 累 代 >

エディアカラ動物によって，多細胞生物は地球のいたるところに広がり，来たるべき多様性の先駆けとなる。

‹ cryptozoïque ›

4　原生代

25億年前から19億年前　最初の生物が，細胞核をもつ生命の形態——真核生物と呼ばれる——をもたらすほどに発展する。大きな四生物界，すなわち原生生物（最初の海藻および繊毛や鞭毛をもつ生物のような真核単細胞生物），将来の多細胞植物，動物，菌類への区分の始まり。

24億5000万年前から21億1000万年前　大陸プレートの新たな接触により超大陸ケノールランドが形成される。

19億年前　大気中の酸素濃度が増大し，ふくらんだオゾン層によって宇宙線に対する防御が強められたおかげで，高等な生命の形態が発展できるようになる。硫黄のような他のエネルギー源に依存する，これまで支配的であった生命の形態は，それらにとって有毒であるこの大気から逃げだし，保護された環境（海底火山のような）のなかに避難するか消滅する。

18億年前から15億年前　ケノールランドの名残をもとにした超大陸コロンビアの形成。

11億年前から8億年前　コロンビアの名残をもとにした超大陸ロディニアの形成。

7億2000万年前から6億年前　さまざまな気候帯の出現。これ以後は乾燥帯や暖海だけでなく，両極の広大な凍結地域も存在する。

7億年前から6億3000万年前　細胞の連鎖をもとにした最初の多細胞生物の形成。

6億2000万年前から5億7000万年前　いくつかの氷期があり，その最後のものは地球のほぼ全体とかかわりをもつ（赤道付近の狭い地帯だけが免れた「スノーボール」期）。単細胞生物の大部分は身を守るすべがなく消滅する。

5億7000万年前から5億4200万年前　全地球が再び暖められ，この氷の覆いを溶かす。再び暖められた海中で光合成活動が盛んになったため，大気中の酸素濃度は著しく増大する。

　原生代の最後の時代のエディアカラ紀には，分類するのが難しい大型後生動物——「エディアカラ動物群」と呼ばれる——が発展する。しかし最初の海綿動物や最初の刺胞動物，および角質の覆いをもつ原始的腕足動物も出現する。刺胞動物は生き残るために，固着性の形態を発展させたり，匍匐したり，自由に泳いだりと，さまざまな戦術を採用する。

〈 古 生 代 〉
カンブリア紀

‹ paléozoïque ›

「肉眼で見える生命の時代」という新たな章が始まる。その住人の化石化する遺骸は，われわれがこの時代の生命について，単なる推測を超えて知ることをしだいに可能にする。

⟨ 古 生 代 ⟩

地球における1日はこれ以後約20時間続く。
また月はかなりの距離まで遠ざかる。

巨大なロディニアはいくつかの大陸プレートに分かれ，
広大な熱帯の海が地球を覆う。

カンブリア爆発の特徴は，それまで見たことのない，信じられないほど多様な生物種が出現したことにある。

‹ paléozoïque ›

‹ 古 生 代 ›

‹ paléozoïque ›

実験に富むこの時代の主要な代表者は，
多くの形態を発展させた三葉虫(さんようちゅう)である。

< 古 生 代 >

これは複眼（レンズの森，多数の個眼）を備えた最初の種族である。

脚が出現し，やがて多くの生物にとって速く移動するためには不可欠のものとなる。

‹ paléozoïque ›

当初の環境はまだ「楽園」のようであった。最初の動物はむき出しのままで餌をとり，武装していない。

しかし食糧が希少になり，競争が常態化すると，いくつかの種族は他の解決策を検討せざるをえなくなる。

バクテリアのカーペットを食したり，プランクトンを濾過したりする代わりに，それらは無防備な同類を食べ始める。

〈 古 生 代 〉

終わりのない軍備競争が始まる。　　　　　鉤爪(かぎづめ)と歯に対抗する背甲(はいこう)と棘(とげ)。

‹ paléozoïque ›

古 生 代

‹ paléozoïque ›

外骨格は殺戮に対する反発である。「発明家たち」は身を守るために珪酸質の代謝廃物を再利用する。

「建築家たち」はしだいに複雑になる殻を構築し，それらはのちに示準化石となる。

密集した群体を形成する。

巨大な礁を構成する。

‹ 古 生 代 ›

‹ paléozoïque ›

現在よく知られているほぼすべての動物門と，こんにちでは詳しく知られていない他の門が出現する。

〈 古 生 代 〉

いくつかの発明は完璧だったので，数億年間は存続する。

充分に発展したこの動物群のなかで，あまり運のなかった
他の志願者はすぐに消滅する。

‹ paléozoïque ›

多くの動物門が著しく進化し，ひとつの型式が登場して大成功を収める……

〈 古 生 代 〉

縄状のピカイアは浅海を泳ぐ。背側に帯をもつそれは，すべての脊椎動物の祖先である。

しかしこの時代の最後に，新たな氷期が海中で大規模な絶滅を引き起こす。

5 顕生累代

5.1 古生代　5億4200万年前から2億5100万年前

5.1.1 カンブリア紀　5億4200万年前から4億8830万年前

5億4200万年前　後生動物のすべての部門が発展する——軟体動物，放射相称動物，環形動物，節足動物，有爪動物，腕足動物，外肛動物，棘皮動物，脊索動物，そして脊椎動物のような，こんにちまだ生存しているすべての動物門が，「カンブリア爆発」と呼ばれる事変のあいだに出現する。他の多くの門が，この時代の終わりか続く時代のあいだに消滅する運命にあるが。

三葉虫（節足動物甲殻類の祖先で三つの葉をもつ）は種が驚くほど豊かであり，個体数が非常に多いためこの時代の示準化石になっている。眼と移動器官（脚，触手，ひれなど）の形成が動物の可動性を著しく高める。最初の肉食動物の捕食行動により競争がさらに激化する。浅海のさまざまな環境への適応は迅速である。いくつかの種は再結集し礁を形成する。光合成の信奉者である原始的な形態は発展し，褐藻など複雑な多細胞の藻類を形成する。

5億3500万年前　熱帯の浅海のなかで生命が大いに繁殖し，殻を備えたサンゴと腕足動物が増加したため，礁が非常に発達し，化石に富んだ地層が出現する。

5億2000万年前　超大陸ロディニアが数個の異なるプレートに分かれ，地球の全表面に割りふられる。そのいくつかの断片は，ゴンドワナと呼ばれる広大な大陸を徐々に形成する。それは将来の南アメリカ大陸，南極大陸，アフリカ大陸の大部分と，マダガスカル島，インドを含んでおり，赤道付近に位置している。他の大きな大陸プレートは，ローレンシア（現在の北アメリカに相当する），バルティカ（現在の北東ヨーロッパ），シベリアのクラトン（剛塊）である。

4億9000万年前　ある激変によって氷期と大量絶滅の波が押し寄せ，この時期の終わりには種数がおよそ50％減少する。

＜ 古 生 代 ＞
オルドヴィス紀

‹ paléozoïque ›

カンブリア紀末の氷期のあとには，並はずれた気候の変動をともなう，地質構造の不安定期が続く。

その間にロディニアのいくつかの大きな名残は再結集し，「南大陸」ゴンドワナを形成する。

＜ 古 生 代 ＞

動物相はゆっくりとしか回復しない。　　礁(しょう)は成長を再開する。　　新たな借家人が新居に入る。

< paléozoïque >

〈 古 生 代 〉

植物相が目覚める。最初の植物が海底の共同体を富ましにくる。だがそれだけではない……

数百万年ののちに，とりわけ順応性のある先駆的な植物が，ゆるい傾斜の潮間帯に危険を冒して進出する。
まったく初めて，比較的複雑な存在が大地に入植する。

‹ paléozoïque ›

その間に，原始的脊索動物は内骨格を備えた最初の脊椎動物を誕生させる。

〈 古 生 代 〉

しかし遠い将来だけが彼らのものであり，この時代は厚い背甲をもつ無脊椎動物の手中にある。

‹ paléozoïque ›

体長が3mもあり，はさみで武装したウミサソリが，海底の新しい支配者となる。

< 古 生 代 >

その子孫には生き残ることに成功する者もいるが，いまのところはそれらも気候の変化に苦しむ。

ゴンドワナが南極に向かって移動する。そしてもう一度巨大な氷河が生物空間を侵略し，氷のなかに閉じ込める。

‹ paléozoïque ›

5.1.2　オルドヴィス紀　4億8830万年前から4億4370万年前

4億8500万年前　極冠が融け，海の水位は300m近くも上昇し，すべての時代で最高の水準に達する。海生動物相は徐々に回復する。

4億7800万年前　植物相も最初の真の植物の出現とともに急速な進化を遂げる。それでも当初それは海底に住みつくだけで満足している。

4億7300万年前　原始的な脊索(せきさく)動物がまだ顎のない最初の魚類を誕生させる。頭足類(とうそくるい)，腹足類(ふくそくるい)，筆石(ふでいし)，コノドント動物が出現する。海綿動物，層孔虫(そうこうちゅう)，サンゴがその一部をなす刺胞(しほう)動物が巨大な礁(しょう)を構築する。礁は棘皮動物(きょくひ)，軟体動物，腕足(わんそく)動物，頭足類によって植民される。頭足類は進化を続けるが，最も重要な変化は節足(せっそく)動物の種族のなかで生じる。

4億7100万年前　体長数mのサソリは最も恐るべき海の捕食者である。

4億6200万年前　コケのような最初の陸生植物が沿岸地帯を征服する（有害な太陽の紫外線から生物を保護する，前代に形成されたオゾン層がいまや充分に発達したおかげで）。

4億5000万年前　ゴンドワナが赤道から南極に向かって漂移し，徐々に凍結するため，この時代の終わりに気候が大きく変化する。新しい氷期の始まりである。氷の蓄えが非常に多くなり，縁海の水位は著しく低下する。これらすべてがあらゆる時代で最大の絶滅の波を引き起こし，地球の生物の95％が犠牲者となる。三葉虫(さんようちゅう)のほぼ全体だけでなく，頭足類，腕足動物，多くの礁も含む多数のオルドヴィス紀動物が殺戮される。

〈 古 生 代 〉
シルル紀

‹ paléozoïque ›

しばしの休息のあと，ゴンドワナは再び漂移し始める。氷の一部は液状に戻り，生命はその流れを再開する。

‹ 古 生 代 ›

最初の魚類である無顎類（むがくるい）がシルル紀に登場する。

それらは歯も顎ももたないが無防備ではない。

骨のほかに保護板を発達させる。

将来の頭蓋のなかには操縦室も。

直接的環境のなかの差し迫った危険や，来たるべき脅威を免れるためにはそれらが必要である。

‹ paléozoïque ›

長さ5mにも達する外套膜をもった，巨大な頭足類には深刻なライバルはいない。

< 古 生 代 >

それは甲殻類、筆石、貝類、サンゴ、棘皮動物、ヒトデ、ウミエラの王国の先頭に立つ。

‹ paléozoïque ›

しかし魚類は武装する。　　　やがて真の顎をもつ。　　　そしてそれらも狩りにでる。

Huch!

〈 古 生 代 〉

‹ paléozoïque ›

これまでバクテリアの群体専用だった沿岸地帯は，少しずつ最初の真の植物によって侵略される。

植物の組織は強化され，茎がそれらを支えるようになり，表面は太陽光線に抵抗し始める。

〈 古 生 代 〉

水を飲むために根を地中に差し込む。　　　　　　　　地表では鋭敏なソーラーパネルを広げる。

‹ paléozoïque ›

こうして原始的植物相は固有の生物空間を構成し，それはやがて最初の奇妙な訪問者によって占拠される。

Palaeocharinus

Rhyniella praecursor

Lepidocaris rhyniensis

‹ 古 生 代 ›

このような発展はこれ以後地上と水中で続けられ，シルル紀は抗争なしに終了する。

5.1.3 シルル紀　4億4370万年前から4億1600万年前

4億3900万年前　シルル紀の特徴は，陸地に対し海が主導権を握ったことにある。気候は基本的に暑く湿潤で，内陸では時に暑く乾燥している。この時代を通じて，活発な火山活動が地殻の新しい層と広大な鉱床を形成する。将来のアメリカと北ヨーロッパで，タコニック造山運動によって山が形成される。アフリカでは，氷の最後の名残が少しずつ消え去る。

4億3700万年前　体長が5mもある巨大な頭足類（とうそくるい）が，食物連鎖の頂点にあるのに対し，進化の期待を抱かせる他の分枝，すなわち脊椎（せきつい）動物の分枝では原始的な魚類が出現する。

4億3300万年前　最初のプシロフィトン（原始的なシダ植物）が，すでに生物の住みついていた沿岸地帯に到着する。リグニン（木質素）とセルロース（繊維素）が堅固な茎をつくることを可能にする。まだ水陸両生であった節足動物が，あえて陸上に進出したことが知られている最初の動物である。

4億2600万年前　サソリや多足類（ムカデ，ヤスデなど）とともに，いくつかの動物目（もく）が保護的な水中から持続的に外にでて，地上の呼吸に慣れると，最初の真の陸地の住人になる。原始的なクモとダニ，トビムシとある種の甲殻（こうかく）類がやがてそれに加わる。

4億2200万年前　シルル紀後期に顎をもつ最初の魚類が現われる。頭足類のあいだでは，螺旋形に巻いた殻をもつオウムガイ（アンモナイトの祖先）が絶頂期を迎える。暑い地域の海では，動物とさまざまなサンゴの数が急速に増加する。それらは大量の二酸化炭素を固定させ，2500km近くも広がることのある，広大な石灰鉱床をつくりだす。

4億1900万年前　ローレンシア，バルティカ，シベリアの大陸プレートが北の始原大陸ローラシアに徐々に近づく。

4億1600万年前　シルル紀の終わりごろ，海が後退し浅海帯が陸地になる。植物の侵入が起こり，最初のプシロフィトンと胞子植物が発達する。当初は葉をつけていないが，やがて葉を想起させる小さな若枝を備えるようになる。原始的なシダとヒカゲノカズラが発達し，最初の沼地が出現する。

〈 古 生 代 〉
デヴォン紀

‹ paléozoïque ›

生存競争の主要な舞台は相変わらず水中であり，生物が占めるさまざまな地位は強化される。

〈 古 生 代 〉

絶滅するまで示準化石をつとめる頭足類(とうそくるい)は，しだいに大きな「アモンの角」を装備する。

‹ paléozoïque ›

< 古 生 代 >

肉食魚類は巨大な歯，保護板，長さ10mにもなる巨体によって対応する。

最大の者は海の要塞に似ているが，やがて直接の隣人との競争をしなければならない。

最初のサメがデヴォン紀後期に出現する……　　　　　　　　　　……そして海の最も有能な捕食者になる。

‹ paléozoïque ›

陸上では植物の形態がますます多様化し，太陽の恵みを奪い合う。

トクサが古生代植物相の顕著な特徴となる。ヒカゲノカズラとシダがやがてそれに加わる。

〈 古 生 代 〉

沿岸地帯の暑い沼地は陸生植物だけでなく，新しい住人の実験場でもある。

‹ paléozoïque ›

キチン質の背甲が最良の防具となる，ますます多くの昆虫が地上を占領し……

……やがて筋肉質のひれに助けられ，敵や他の脅威から逃れる最初の魚類があとに続く。

〈 古 生 代 〉

‹ paléozoïque ›

この進化の最も有名な例は，およそ4億年も生き延びるシーラカンスである。

< 古生代 >

ひれが脚に，えらが肺に変化し，脊椎動物の新しい綱が出現する。

‹ paléozoïque ›

陸生動物の先駆者であり，陸地の奥にまで侵入した最初の脊椎動物である両生類。

〈 古 生 代 〉

無脊椎動物においても進化は加速し，たちまち空さえも征服される。

しかしその前に，ゴンドワナが新たに南極へ向かって漂移し凍結するので，中規模の絶滅が発生する。

‹ paléozoïque ›

5.1.4　デヴォン紀　4億1600万年前から3億5920万年前

4億1600万年前　デヴォン紀は魚類の時代だと考えられている──原始的な無顎類はたしかに消え去りつつあるが，とくによく装甲された綱（板皮類）は大発展を遂げる。この種族の分枝から最初の軟骨魚類（サメとエイの祖先）と条鰭類（最初の「真の」魚類の祖先）が誕生する。

4億1200万年前　カレドニア造山運動の結果，ゴンドワナと対をなすローラシア大陸が形成され，それはのちに北アメリカとグリーンランドとユーラシア北部を生みだす。

4億900万年前　頭足類に属するオウムガイは最初のアンモナイトを誕生させ，それは続く3億年間示準化石になる。礁群集は発達し続け，ますます堂々とした建造物を構築する。

4億300万年前　魚類のあいだで，脚に似た，5本指のひれ2対をもつシーラカンスのような形態は，上位の脊椎動物への過渡的な役割を果たしている。軟骨魚の綱においては，棘のあるサメが絶頂をきわめている。

3億9100万年前　トクサとヒカゲノカズラのさまざまな形態のほかに，プシロフィトンが出現する。最初の樹木はすでに高さが数mに達し，単純な森林の生態系を形成している。

3億7400万年前　とくに移動と呼吸において適応することに成功したのち，最初の両生類があえて陸地に乗りだす。陸上はすでにこの時代のはじめに，まだ翅のない昆虫によって征服されている。

3億6200万年前　ゴンドワナが新たに南極を通過し，徐々に氷に覆われる。新しい氷期が数百万年間大陸の大部分を幽閉し，動物相と植物相を破壊し，熱帯の礁群集を崩壊させる。

〈 古 生 代 〉
石炭紀

‹ paléozoïque ›

南極はいまや超大陸ゴンドワナを解放し，ゴンドワナは対をなす北の大陸と出会うためにやがて出発する。

〈 古 生 代 〉

海面は上昇し，地球は発汗し，温室的気候は地球全体に広大な森林を成長させる。

‹ paléozoïque ›

〈 古 生 代 〉

‹ paléozoïque ›

2000万年にわたり，有機廃棄物の厚い層が形成され，大量の炭素が固定される。

〈 古 生 代 〉

とくに将来の北アメリカとユーラシアにおいて，化石燃料の豊かな蓄積がつくられる。

豊富な植物が呼吸しながら二酸化炭素を分解するので，大気中の酸素濃度は2倍になる。

‹ paléozoïque ›

この植物の楽園に動物がいないわけではない──地上，空中，水中のすべての居住可能な片隅には動物があふれている。

数え切れないほどの節足(せっそく)動物が住みつき，移動手段をたえず改良する。

〈 古 生 代 〉

‹ paléozoïque ›

この間に，最も発達した四肢動物は，陸上生活への完全な適応に向けさらに一歩を踏みだす。

骨と筋肉の系統が最適化し続ける。　　やがて狩りを□□する最初のトカゲ類の姿が見られる。

〈 古 生 代 〉

< paléozoïque >

殻に包まれた保育器である卵が，トカゲ類を水生の環境から自由である最初の脊椎動物にする。

〈 古 生 代 〉

この間に水中では，深刻なライバルなしに機能する，サメの流体力学的形態が鮮明になる。

最もすらりとした形の種が，海からでて淡水のなかのしだいに遠くへも進出する。

‹ paléozoïque ›

しかし地球は新たに変貌する。　　　天と冥界が目を覚ます。　　　時代は大量絶滅によって終わりを告げる

〈 古 生 代 〉

沼沢林の生い茂る生物空間で見られるように，適応できない種は消え去る。

堆積岩のなかに捕らわれた化石が残る。

そして処女林の分厚い地層が石炭に変質する。

‹ paléozoïque ›

5.1.5　石炭紀　3億5920万年前から2億9900万年前

3億5700万年前　ゴンドワナが南極から遠くへ漂移し解氷したため，海水準は著しく上昇する。一般に地球全体の気候は徐々により湿潤に，また初期にはより暑くなる。

3億4400万年前　デヴォン紀に形成された北の大陸ローラシアは，しだいに南の大陸に接近する。それまで南極のまわりを回転していた南の大陸は，いまや北へ向かって漂移する。そのため次の時代まで続くヘルシニア造山運動と，二つの超大陸の接合が開始される。

3億4200万年前　石炭紀は両生類の時代となる。体長3mに達することもある，背甲をもつ巨大な種によって，両生類はこれまでで最大の陸生動物である。この種族のひとつの分枝が，やがて最初の爬虫類を誕生させる。

3億2300万年前　50mにまで達することのある，ヒカゲノカズラ，レピドデンドロン（鱗木），シギラリア（封印木）で構成された広大な沼沢林が，高さ数kmにもなる石炭の膨大な蓄えを形成する。それがこの時代に石炭紀という名称を与えている。

3億1100万年前　飛翔する昆虫のあいだに最初のトンボが登場したが，そのうちのいくつかの巨大な形態は翅幅が75cmに達することもある。多足類もしだいに大きな種を発達させ，最大のものは体長2m以上になることもある。

3億800万年前　デヴォン紀に地球大気の酸素濃度が15%でしかなかったとするなら，その後それは大量の植物のおかげで35%に達する。しだいに洗練された生物空間が，多様な相互依存と複雑な食物連鎖とともに出現する。

3億700万年前　新陳代謝と生殖の変化や，とくに卵の発達のおかげで，直接の祖先がまだ両生類である，最初の爬虫類的四肢動物が水生の環境から完全に独立する。それらはこれ以後，乾燥した内陸の征服に向けて出発することができる。

3億300万年前　石炭紀後期には隕石の衝突と火山活動のため，平均気温は全地球でかなり下がる。極冠と氷河の量が新たに著しく増加するので，海水準が非常に低下する。動植物の多くの種はこのような根本的な変化に抵抗できない。しかし石炭紀の終わりとともに，とくに広大な熱帯林が消滅する。

〈 古 生 代 〉
ペルム紀

‹ paléozoïque ›

385 mya　　　　325 mya　　　　245 mya

ローラシアとゴンドワナが結合する——新しい超大陸パンゲアが誇らしげに北極から南極まで広がる。

降水はもはやこの広大な大地の内陸にはほとんど到達せず，敵対する砂漠がそこに発達する。

< 古 生 代 >

涼しく乾いた気候が定着し，斬新な生き残り戦略を発展させる。最初の球果植物やイチョウのような，裸子植物が登場し，昆虫の繁殖は幼虫期を経過するようになる。

‹ paléozoïque ›

トカゲ類は鱗のコートを身につけ，卵殻を硬くすることによってこの変化に対抗する。

その代わり湿潤な生物空間では，両生類が巨大な代表例を登場させて新しい飛躍を遂げる。

‹ 古 生 代 ›

水中では鋭い歯をもち耐久力のあるダイバーの，メソサウルスが新たな捕食者になる……

……それに対し木々のあいだで生活するいくつかのトカゲ類は，これまで昆虫専用であった空中に飛びだす。

‹ paléozoïque ›

原始的爬虫類の子孫である単弓類は，変化に富んだ種族を形成しパンゲアの支配的グループとなる。

それらは一定の体温を維持する最初の動物であり，厳しい気候に耐えることが可能になる。

〈 古 生 代 〉

それらは不器用な草食動物も敏捷な肉食動物も生みだし，前途有望な生活様式のひな型を示す。

‹ paléozoïque ›

そのなかで最も進化した獣弓類(じゅうきゅうるい)はもはや爬虫類ではなく，むしろ哺乳類に似ている。

〈 古 生 代 〉

その子孫のなかのキノドン類は，哺乳類の内的・外的特徴を数多く含んでいる……

Reptilia　　　　　　　Cynodontia　　　　　　　Mammalia

それでもこのような発展は突然の終結を迎える。史上最大の激変が生じたからである。

‹ paléozoïque ›

超巨大火山の時限爆弾が爆発する——数百万平方kmにわたりシベリアは途方もない溶岩流に覆われ，数十万トンの石と灰が空中に吐きだされる。

〈 古 生 代 〉

生物圏は完全に攪乱され，古生代は種の決定的絶滅の波に見舞われて終わりを告げる。

‹ paléozoïque ›

5.1.6　ペルム紀　2億9900万年前から2億5100万年前

2億9600万年前　重大な気候変化が不意に生じる。ローラシアとゴンドワナの二つの巨大な大陸はすでに融合した。バルティカとシベリアのようなより小さなプレートも大地の巨大な広がりに繋がれる。こうして地球は二つの部分に分けられたように見える。ひとつの部分はパンサラッサ海に覆われ，もうひとつの部分はほぼすべての緯度におよぶ超大陸によって構成される。

2億8100万年前　パンゲアと名づけられたこの超大陸の中央は極端に乾燥し，水を好む胞子体は生き残れない砂漠が形成される。植生は最初の球果植物やイチョウのような，裸子植物をつくりだすことで対抗する。その繁殖戦略はより適応し，蒸発によりよく抵抗することが判明する。爬虫類と昆虫の方は，硬い殻をもつ卵や幼虫のような，水生の環境とはまったく独立した中間的段階を導入することにより，繁殖の方法を変更する。

2億8000万年前　浅海は乾燥するうちに広大な岩塩鉱床をあとに残す。

2億7400万年前　多くの草食動物だけでなく肉食動物も含み，その代表者はしだいに巨大化する獣弓類の集団が地上を支配する。堅頭類（迷歯類ともいう）が，あらゆる時代で最大の両生類であるマストドンサウルス──体長が4mに達することもある──によって湿潤な生息環境に君臨し続けるが，やがて後退を余儀なくされる。

2億6800万年前　現生のトカゲを思い起こさせる小型のトカゲ類が獣弓類の影に登場する。それらはまだとるに足りない食虫性動物の小さな個体群でしかない。

2億6600万年前　パンゲアが中央で裂け始める。地中海の祖先であるテチス海によって，全地球的海洋が超大陸の中心まで届く入江を形成する。海水準にしたがえば，それは東南アジアから将来の中央ヨーロッパまで広がると考えられる。この時期の海洋は地球の全歴史のなかで最も低い海水準を経験する。

2億5900万年前　滑翔する爬虫類の原始的な形態が空中に乗りだす。

2億5700万年前　キノドン（ギリシア語でイヌの歯の意味）類を含む獣弓類のいくつかの分枝で，とくに骨格と移動の方法と新陳代謝において，哺乳類との類似がますます明らかになる。

2億5200万年前　信じられないほど激しい火山活動（これが原因でシベリアに，数百万平方kmの面積にわたって新しく密な玄武岩層が形成される）が温室効果をもたらし，すでに非常に暑かった世界の気候を長期間さらに暑くする。この変化には海水準の大きな低下がともなう。

　この大変動が恐るべき絶滅の波を引き起こす。この絶滅は古生代植物相の大部分，原始的爬虫類と獣弓類のほぼすべて，多くの両生類とアンモナイトとサンゴと放散虫，さらにはまだ生存していた三葉虫のすべて──すなわちすべての種の90%──に関係し，生態系全体の崩壊を生む。きわめてわずかな時間のうちに，海の生物多様性はおよそ25万種から1万種以下に減少する。

< 中 生 代 >
三 畳 紀

‹ mésozoïque ›

陸上の生命はこの激変からゆっくりとしか回復せず，生態的地位は少しずつにしか埋まらない。

それでも多くの生き残りは，この新しい状況が提供する前代未聞の機会を利用できるようになる。

〈 中 生 代 〉

すでに哺乳類に似ていたキノドン類は増殖し，洞窟のなかで生活する共同体を形成する。

状況はすべてにとって同一なので，似た生息環境からは類似した構築のプランが出現する。

42 mya

87 mya

0 mya

‹ mésozoïque ›

より適応した爬虫類の新しい形態が登場し，それより原始的な獣弓類は追い払われる。

主竜類は先行者たちより速く器用，より強く耐久力があり攻撃的である。

主竜類はこの権力交代のゆるぎなき勝者である。　　その骨格がきわめて多様な発展を可能にする……

〈 中 生 代 〉

……それらは巨大なワニから，立って二足歩行するはるかにきゃしゃな形態にまでおよぶ。

「主竜」はまさしくその名にふさわしい……　　　　　　　　　……やがてあらゆる環境で使用人を徴募する。

‹ mésozoïque ›

すぐにそのうちの数種は大洋での冒険に再度乗りだす。　　　　　そして水生の環境に挑戦する。

Jenny Haniver
» Historia Animalium «
(1551 - 1558)

‹ 中 生 代 ›

やがて板歯類、ノトサウルス、イクチオサウルス（魚竜）が形態的収斂のおかげで理想的な適応を果たす。

‹ mésozoïque ›

他のトカゲ類は最終的テスト飛行を何回か行なったのち，すぐさま空中の支配者となる。

A B C D E

254

〈 中 生 代 〉

第4指から張られた皮膜のおかげで，空飛ぶトカゲ類は支障なく全地球に広がる。

‹ mésozoïque ›

気候はより湿潤になり，この時代の植物ばかりか他の生物の役にも立つ。

ある種のワニの子孫が二足歩行し，最初の真の恐竜がいまや登場する。

〈 中 生 代 〉

他の脊椎(せきつい)動物より柔軟かつ聡明なそれらは，やがて食物連鎖の頂点に戻る。

< mésozoïque >

獲物とされやすい者の一部は，完全武装したこの狩人から身を守るために丈夫な盾を発達させる。

この狩人の典型例はますます大きく強くなり……　　　　　　……長いこと地球の支配者であろう。

< 中 生 代 >

並行して最初の哺乳類が発達するが，1億5000万年間ネズミのサイズを越えない。

‹ mésozoïque ›

恐竜は新しいグループを発展させ続け，近縁の者に比べてますますよく適応する。

〈 中 生 代 〉

三畳紀後期の生態的激変がライバルを排除し，恐竜たちに新しい時代への道を開く。

‹ mésozoïque ›

5.2　中生代　2億5100万年前から6550万年前

5.2.1　三畳紀　2億5100万年前から1億9960万年前

2億5100万年前　三畳紀の始まり。三畳紀という名称は，この時代がブントザントシュタイン（雑色砂岩），ムッシェルカルク（貝殻石灰岩），コイパー（雑色泥灰岩）という三つの層序単元で構成されていることに由来する。

2億4800万年前　パンゲアが北方に漂移し，より好ましい気候条件になる。テチス海はほぼ赤道の緯度にある。将来の東南アジアに相当するゴンドワナの断片が，大陸から離れ始める。強烈なモンスーンがその北半分に吹き荒れ，内陸で湿気が増す。にもかかわらず三畳紀の気候は主として暑く乾燥し大陸的である。

2億4500万年前　シダやトクサのような先駆的植物が砂漠地帯を再び征服する。四肢動物はもともと基本的に草食だが，いまや急速な進化を経験する。小さく敏捷なキノドン類が脊椎動物の集団を数において支配する。いくつかの地域では，発見される化石の大部分をそれらが占めるだろう。

2億4300万年前　海水準が上昇し，海生動植物相の進化は新たな飛躍を遂げる。

2億4200万年前　海底の動物相は再生し，貝殻石灰岩（ムッシェルカルク）の巨大な礁を構築する。サンゴやウニのほかに，頭足類から発達したアンモナイトやベレムナイトが絶頂をきわめ，3000種以上を有するようになる。

2億4000万年前　新たな捕食者である主竜類がしだいに存在感を増す。ときに後脚で立って歩くとくに脚の長い一種のワニが，重々しく装甲しているか，反対にほっそりとして敏捷である典型例とともに陸地の支配者となる。

2億3900万年前　さまざまな進化の道をたどり，爆発的に発展したトカゲ類のいくつかの種族が，水中という往時の生息環境への道を再びとる。それがとくに魚類に似たイクチオサウルスや，脚をひれに進化させたプレシオサウルス（首長竜）の場合である。後者は巨大な形態を急激に発達させ（体長25mにまで達する），胎生である。

2億3300万年前　球果植物が重要な進化を経験する。アラウカリア，イトスギ，イチイ，マツが登場する。木生シダやヤシとイチョウが，おずおずと再び広がり始めた森林を富ましにやってくる。

2億2500万年前　二足歩行の主竜類が最初の真の「恐るべきトカゲ類」すなわち恐竜を誕生させる。捕食にほぼ専念し，もともとは肉食であるそれらは，主竜類が排除され新しい生態的地位が解放されると，どっしりした草食の典型例も発達させる。

2億2100万年前　第4指の著しい伸長と，しだいに大きくなり脚とつながった皮膜のおかげで，最初の翼竜が飛翔を始める。恐竜は二つの主要な目に分けられる。爬虫類の骨盤をもつ竜盤目と，骨盤が将来の鳥類の骨盤に似ている鳥盤目である。

2億1800万年前　南北中国の地塊が衝突し，秦嶺山脈が形成される。

2億1500万年前　小さく毛むくじゃらであるキノドンのいくつかの形態が，完全に最初の哺乳類を誕生させる。それはまだハツカネズミのサイズの卵生食虫類でしかないが，しだいに子供の世話をするようになる。

2億1200万年前　気候の変化が海水準の新たな低下と，浅海の干上がりをもたらす。塩湖と広大な岩塩鉱床が残される。

2億900万年前　マニクアガン・クレーター（現在のケベック州にある）が巨大隕石の衝突によって形成される。

2億300万年前　重大な環境の変動が，主竜類のような原始的爬虫類の集団と，とくに最後の獣弓類の消滅を引き起こす。

‹ 中生代 ›
ジュラ紀

‹ mésozoïque ›

それらの代表者はしだいに威圧的大きさになる。　　　　体長45m，体重90トン，そしていかなる限界も見えない。

< 中 生 代 >

DIPLODOCUS Sauropoda (Diplodocida)
Time: 154 – 144 mya
Size: at least 28 m
Weight: ca. 15 t

それでも骨格の見事な適応のおかげで，この巨体には機動性が残っている。

‹ mésozoïque ›

〈 中 生 代 〉

‹ mésozoïque ›

何ものも彼らの口をまぬがれない——非常に長い首をもつため，アラウカリアの天辺の梢にも届く。

しかし脚の上のこの大量の肉はそれ自身が獲物であり，より大きな捕食者の注意を引く。

〈 中 生 代 〉

それでも恐竜は，堂々とした体軀の典型例を誕生させる
唯一の種族ではない。

ほぼすべての爬虫類は最適の環境を利用して
一種の競争に専念する。

‹ mésozoïque ›

海生トカゲ類も体長約25mの巨大な形態によって新記録を樹立する。

〈 中 生 代 〉

翼竜もまたよく発達する。もはや交尾と産卵のためにしか地上に降りてこない。

スズメのサイズから遊覧飛行機のサイズまであるそれらの翼は，広げたときの幅が12mになることもある。

‹ mésozoïque ›

地面や木々の枝のあいだで，空中の支配者がまだ気づいていないライバルが準備される。

というのもトカゲ類のいくつかの種族は，原始的な鱗（うろこ）からつくられた羽毛という革命的な新機軸を利用するのだから。

数百万年のうちに，その種族は軽くなり，羽毛で覆われ，前脚は力強い翼に変化する。

〈 中 生 代 〉

‹ mésozoïque ›

跳躍したり飛翔したりする典型例が，歯と鉤爪をまだ備えた最初の鳥類を誕生させる。

〈 中 生 代 〉

この進化の段階の役者たちは，紆余曲折を乗りこえて，　　　数百万年祖先たちより長生きをする。

‹ mésozoïque ›

地上のゆるぎない支配者は攻撃的かつ敏捷な捕食者で，あらゆる気候帯を占領する。

〈 中 生 代 〉

この間にも大陸プレートは常に動き，重大な変化が突発する。

テチス海が大陸の北半分と南半分のあいだにしだいに深く進入する。だがそれがすべてではない……

‹ mésozoïque ›

パンゲアの下で作用する張力に屈し，両半分のひとつが
独自の道をたどる。

地殻が裂け，海水が東の部分と西の部分のあいだに呑み込まれ
新しい海洋の大西洋が出現する。

〈 中 生 代 〉

この大量絶滅の記録として，地層の薄層のなかに特異な層が残っている。

大変動が始まる。　　　　　　　　　　　　　　世界の気候が新たに決定的変化を経験する。

この大量絶滅の記録として，地層の薄層のなかに特異な層が残っている。

‹ mésozoïque ›

5.2.2 ジュラ紀　1億9960万年前から1億4550万年前

1億9900万年前　ライアス世と呼ばれる比較的涼しい前期のあと，ジュラ紀の気候は絶えざる暑さと強い湿気を特徴とする。海水準は著しく変動するが，全体としては三畳紀より高い。広大な浅海が大陸の沿岸地帯を水没させ，これは広大な礁の群落のような，海洋共同体の新たな開花にとっては理想的な条件である。続く数億年間に，バイオマスとくに中生代の沿海（とりわけゴンドワナの北岸）に堆積するプランクトンの死骸が，厚さ数百mの地層を形成することになる。その後の圧縮と変換の過程が，世界中の石油と天然ガスの鉱床をつくりだす。

1億9700万年前　砂漠が進行を停止するだけでなく，沼地と密林の大きな前進が砂漠を後退させる。球果植物は征服を続け，シダ種子植物（シダ植物と種子植物の中間型）を駆逐する。

1億9600万年前　三畳紀の種族が最初の現代的なカエルを誕生させる。

1億9400万年前　おそらく恒温性の（したがって変温性の四肢動物より有利な）恐竜が，赤道から熱帯を経由して亜極圏までのあらゆる気候帯を征服する。それでもトカゲ類の他の目のために海と空を残す。

1億8900万年前　テチス海によって満たされたローラシアとゴンドワナのあいだの割れ目は，一時的にパナマまで拡大し（そのためのちにメキシコ湾が形成される），超大陸パンゲアの新たな解体ともいえる事態を引き起こす。

1億8800万年前　最初の海生のカメと最初の海生のワニが出現する。

1億8600万年前　草食恐竜の竜脚類が最大の陸生動物になる。ブラキオサウルスやセイスモサウルス（「地震トカゲ」という意味深い名前をもつ）は長い首のおかげで木々の天辺の梢にも届き，その食習慣がジュラ紀の植物相を変化させる。

1億8400万年前　獣脚類（二足歩行の陸生肉食動物）がますます力を得る。ジュラ紀におけるその最大の代表者は，体長12mにも達するアロサウルスである。

1億8000万年前　すさまじい地震が一方では南北アメリカのあいだで，他方ではユーラシアとアフリカのあいだで，すでに存在していた裂け目や割れ目を接合し，1万kmの長さの構造角礫（激しい破砕作用によってできた角礫）を形成する。狭い入江が出現する。大西洋の誕生である。マントルから上昇する大量のマグマが海底を更新し続ける。すでに分かれていたプレートはますます離れ，地球で最大の山脈である大西洋中央海嶺が形成される。

1億7400万年前　アンモナイト，オウムガイ，ヤリイカ，ベレムナイトはジュラ紀の海のなかで新たな盛期を迎える。硬骨魚（真骨類）が発展し続ける。柔軟な鱗をもつ現代的な魚類の最初の種族が登場する。

1億6900万年前　最初の真の哺乳類（すでに胎生の有袋類だが，体長は10から15cmしかなく，主に夜行性で，ミミズや昆虫などを追っている）が，授乳や子供の世話，さらに中耳の小骨や顎のような特性を完成させる。それらは体毛，恒温性，すぐれた視力などのおかげで夜間の生活にも適応する。

1億5300万年前　「隠された種子」をもつ顕花植物である，最初の被子植物（マグノリアのような）が発達する。

1億5000万年前　二足歩行の肉食恐竜であり，すでに羽毛をもっていたマニラプトル類が，最初の鳥類を誕生させる。この進化の最も有名な代表者である始祖鳥は，歯と鉤爪をもち，まだ爬虫類と鳥類の中間に位置する。昆虫においては最初のシロアリが出現する。

1億4700万年前　南極大陸，南アフリカ，北アメリカ東部における激しい火山の噴火が厚い玄武岩質溶岩層の形成を促す。これまで最適であった生活環境は大きく変質する。

1億4600万年前　きわめて不安定な気候が抵抗力の弱い種の消滅を引き起こし，白亜紀への推移をしるしづける。最後の数百万年，とくにジュラ紀末の絶滅の波のあいだに積もった生物の遺骸が，石灰岩と片岩の厚い堆積物を構成し，そこには完全に保存された化石が埋め込まれている（スコットランドから将来のアルプスまで，ヨーロッパのほぼいたるところで発見されるように）。

〈 中 生 代 〉
白亜紀

‹ mésozoïque ›

白亜紀のはじめに新たな避難所が登場する。森林と沼地が極圏にまで広がる。

⟨ 中 生 代 ⟩

それでも植物相は相貌を一変させる。　　　　　　　　　　現代的な成長と繁殖の方法が確立する。

Trollius europaeus　　　　　　Thujopsis dolabrata　　　　　　Allium ostrowskianum

並はずれて多産な温室的気候が，顕花植物（けんか）と昆虫に対して並行的な進化を引き起こす。

‹ mésozoïque ›

顕花植物は色と香りを餌として利用する。　　　　昆虫は蜜をあさり，花粉を運んで受粉させる。

Silvianthemum suecicum

286

< 中 生 代 >

ミツバチとアリ，および最も多くの種を抱える動物目の甲虫類が登場する。

< mésozoïque >

恐竜の王朝は相変わらずゆるぎない支配を保ち，ますます奇妙な典型例を発達させる。

角をもつ者。　　　　　　　　　　　　　　　　　装甲された者。

〈 中 生 代 〉

鳥をまねた者。

鉤爪(かぎづめ)のある者。

‹ mésozoïque ›

Parasaurolophus Lambeosaurus Saurolophus Kritosaur

発見された化石から確実な年代順の分類は得られないにしても，とっぴな形態の恐竜も，熱心に子供の世話をする無害な菜食主義者であることが多いのはほぼ確かである．

< 中 生 代 >

食物連鎖の頂点に立つための永遠の闘いは，水中を含めたいたるところで続けられる。

‹ mésozoïque ›

〈 中 生 代 〉

海洋はバイオマスを生産し続ける。何千トンもの微生物が海底に沈積し，堆積層に覆われたチョーク，石灰岩，石油の蓄えをつくりあげる。

‹ mésozoïque ›

陸上ではティラノサウルスのような，肉食獣脚類のますます威圧的な代表者が発展する。

〈 中 生 代 〉

‹ mésozoïque ›

それらは他の脊椎動物，とくに哺乳類や鳥類のような，進化の計画において未熟な者たちの行動を妨げる。

自分たちを対象とする不断の狩りに対し，哺乳類や鳥類はきわめて感覚の鋭い，敏捷で小型の形態を発展させ……

〈 中 生 代 〉

……適応を可能にし，非常に高い繁殖率を用いて，解放された生態的地位を占めようとする．

‹ mésozoïque ›

だが直径10kmの岩と氷の塊の形で，次の大量絶滅が近づいてくる。

メキシコ湾の南に位置する石灰岩の堆積のなかに，衝突によって巨大なクレーターがうがたれるだけでなく……

VOOMP!

< 中 生 代 >

……その後に続く地震とともに，すべてを激変させる一連の火山活動も始動する。

岩と灰の巨大な雲がこの地獄から立ち昇り，恐竜が繁栄したこの時代を終結させる。

‹ mésozoïque ›

〈 中 生 代 〉

嵐の吹きすさぶ暗い空の時期が始まり，数千年間続く。天と地のより調和のとれた力関係がようやく築かれたとき，
世界は完全に変わっていた……

‹ mésozoïque ›

5.2.3　白亜紀　1億4550万年前から6550万年前

1億4400万年前　北の大陸から分離したあと，ゴンドワナは南アメリカ，アフリカ，インド，オーストラリアそして南極大陸という，異なる部分に分かれ始める。それらのあいだの陸橋のおかげで，動植物界の交流はまだ可能である。最も小さなオーストラリア大陸が数千万年のうちに最初に完全に孤立させられるため，そこでは居住生物の独自性が生じる。

1億4300万年前　温室効果ガスの著しい濃縮により，世界の気候は新たにきわめて暑いが乾燥したものになる。白亜紀は全地球史のなかで最も暑い時期だと考えられている。極冠と大部分の氷河が融け，海水準は非常に高くなる。

1億4100万年前　植生が変化する。ヒマラヤスギとセコイアが，シダとイチョウと古い球果植物の地位を奪う。顕花植物は発展を加速させ，それを受粉させる昆虫と並行して進化しながら世界の征服へと向かう。灌木状の形態が，イチジク，ヤナギ，ポプラ，プラタナスを誕生させる。カメムシ類の形態から，スズメバチ，ミツバチ，アリのような膜翅類と甲虫類が出現する。

1億3500万年前　とくに北半球では恐竜のあいだで，竜脚類とステゴサウルスが，装甲されたアンキロサウルス，イグアノドン，アヒルのくちばしをもったり角の生えたりした恐竜に徐々に席を譲る。

1億3000万年前　最初の有胎盤類が哺乳類のあいだに登場し，それ以後世界中で，原始的な近縁である卵生の単孔類（カモノハシ，ハリモグラなど）や有袋類と生息環境を奪い合う。

1億2800万年前　群生する最初のアリの化石はこの時期に始まる。

1億年前　海水準は「標準」より170mも上にある。浅海が大陸の境界の広大な部分を覆い，動植物相の新たな飛躍を可能にする。数百万年前から海底に堆積した石灰質の覆いをもつ微生物が，この時代の名称のもととなる，チョーク（白亜）の膨大な堆積を世界中に形成する。世界に広がる石油と天然ガスの蓄えの大部分がつくられる。

9800万年前　マントル内部の変わりやすい対流が新しい海嶺を創造し，大陸プレートはたがいに遠ざかる。この現象には激しい火山活動がともなう。ゴンドワナは分裂し続ける。マダガスカルが北方へ漂移するインドと，ニュージーランドがオーストラリアと分離する。北方では大西洋の新しい湾が，大ブリテン島をラブラドルとニューファンドランドから，ノルウェーをグリーンランドから分離する。チベットと東南アジアとの衝突が山脈の形成を促す。

9400万年前　海中では，体長15mに達することもある，高性能の捕食性トカゲの一種モササウルス類が出現する。同時にプレシオサウルスと巨大なカメが幅をきかせるが，こんにち硬骨魚の支配的な集団である最初の真骨類もいくつかの巨大な形態を発達させる。無脊椎動物においてはアンモナイト，二枚貝類，腹足類（巻貝，ウミウシ，カタツムリなど）が非常に広まる。

8300万年前　飛翔し歩行できる形態以外に，鳥類は水中での生活に適応した，潜り泳ぐことのできる典型例も発達させる。

7500万年前　獣脚類においてティラノサウルス類が発達する。その主要な代表者は，体長12mにも達することがあるため，最大の肉食恐竜のひとつとされるティラノサウルス・レックスである。

7000万年前　白亜紀の終わりごろ，激しい火山活動のため地上のいたるところで生活環境が悪化する。多くの動植物種が死滅するか著しく衰弱する。海は後退し，四季によって特徴づけられるより寒冷な気候が定着する。これはそれまで支配的だった大型爬虫類には適さないが，鳥類や哺乳類や顕花植物の飛躍を引き起こす。

6550万年前　直径10kmの隕石がユカタン半島の北で地球に衝突し，メキシコ湾内に直径約180kmのクレーターをうがつ。数十億トンの岩石が砕け散る。煤や灰が大気中に舞い上がり，数千年にわたって空を暗くする。高さ100m以上の一連の津波が陸地を襲い，多くの沿岸地域を荒廃させる。大規模な地震が火山活動をさらに強める。インドの中央にある広大なデカン高原は大量の溶岩に覆われる。全地球に影響をおよぼしたこの激変は，すべての恐竜の絶滅と，アンモナイトや木生シダのような中生代動植物相の代表例の絶滅を引き起こし，全体ですべての種の70％以上が失われる。

〈 新 生 代 〉
第 三 紀

‹ cénozoïque ›

生物圏は再編されなければならない。他の多くの生命の形態とともに，地球の「中世」の最も重要な代表者である恐竜は，
最後の数百万年の大変動のあいだにすべてが命を奪われてしまう。

< 新 生 代 >

その大変動に直面しても無事であった動物の科は稀である。　　万能家はしばしば最もよく適応する者である。

長いあいだ生命は硬直しているように見える。　　しかし活力のある新しい環境が発展する。

‹ cénozoïque ›

鳥類は「恐ろしいトカゲ類」の正当な後継者である。空いた玉座に苦もなく身を落ち着ける。

〈 新 生 代 〉

‹ cénozoïque ›

存在するのは4mもある捕食者だけではない。

非常に小型のスズメ類もこの状況を利用する。

< 新 生 代 >

かつて遍在したトカゲ類のくびきから解放された，哺乳類も繁栄し，急速に大型化する。

このような最初の陸生胎生動物は，しかしながら生まれたばかりの子供に授乳し，その世話をしなければならない。

‹ cénozoïque ›

これは大胆な実験と，その後1000万年続く漸進的統合の段階の始まりである。

齧歯類が最初に急速に増殖する。

次に続くのが有蹄類，ナマケモノ，コウモリ。

< 新 生 代 >

それらは白亜紀末の絶滅によって空白にされた，あらゆる生態的地位をためらいなく占領する。

最初の肉食動物はやがてイヌ類とネコ類に分かれ，多くの獲物を追いかける。

« cénozoïque »

		Marsupialia	Edentata	Pholidota	Lagomorpha	Rodentia	Primates	Dermoptera	Chiroptera	Insectivora
CENOZOIC	Pleistocene									
	Pliocene									
	Miocene									
	Oligocene									Creod
	Eocene						Proteutheria			
	Paleocene									
MESOZOIC	Cretaceous		Holoclemensia			Aegialodon				
	Jurassic		Symmetrodonta		Pantotheria		Kuehneotherium			
	Triassic									

< 新 生 代 >

Carnivora　Cetacea　Tubulidentata　Artiodactyla　Perissodactyla　Hyracoidea　Proboscidea　Sirenia　Monotremata

Litopterna

Notoungulata

Desmostylia

Astrapotheria

Embrithopoda

Tillodontia

Amblypoda

Taeniodonta

Condylarthra

Multituberculata

Docodon

Trigonodontia

Eozostrodon

Haramiyida

‹ cénozoïque ›

ある種の原始的有蹄類は水生の環境にあえて戻り，脚を徐々に失い泳ぐことを覚える。

〈 新 生 代 〉

適応の法則はそこでも運用され，数百万年後にはイルカとクジラが登場する。

‹ cénozoïque ›

〈 新 生 代 〉

‹ cénozoïque ›

バイオマスが広大な森林に蓄積され，数百万年のうちに石炭の膨大な蓄えとなる。

< 新 生 代 >

石炭やコハクのなかに，植物と昆虫の歴史の痕跡が完全に固定され保存される。

‹ cénozoïque ›

Holcus lanatus

その間に，新たにより冷涼で乾燥した気候が森林を後退させ，広大なむき出しの地表を出現させる。
小さな革命の時期が訪れたように見える。草本植物が世界の征服に向けて乗りだす。

哺乳類があとに続く。限りなく広がる風景のなかで，大型哺乳類は真の巨獣となる。

⟨ 新 生 代 ⟩

acotherium　Mesohippus　Parahippus　Merychippus　Pliohippus　Equus

かつて森林に執着していた種族がそこを離れ，ステップの堂々とした住人になる。それがウマの場合である。

‹ cénozoïque ›

Deinotherium (5 mya)
Gomphotherium (20 mya)
Phiomia (35 mya)
Moeritherium (50 mya)
Mammuthus (1 mya)
Elephas maximus (0 m)

長鼻類(ちょうびるい)も並はずれた飛躍を遂げ，敬意を払わずにはいられない巨大な形態が登場する。

〈 新 生 代 〉

‹ cénozoïque ›

この間にも大陸のジグソーパズルがたえまなく進行する。狭い地峡が新たに二つのアメリカを結ぶ。

山が形成され続ける。ヨーロッパ，アフリカ，アジアのプレートがますます急速に接近する。

324

〈 新 生 代 〉

全世界の気温が数度下がり，第三紀は厚い氷の層のもとですみやかに消え去る。

5.3 新生代　6550万年前から0万年前

5.3.1　第三紀　6550万年前から180万年前

6300万年前　気候，海流，天と地の力関係がほぼ安定するためには，暁新世のおよそ250万年が必要である。

6200万年前　大西洋の拡大は急速に進行する。アイスランドが大西洋中央海嶺の「ホットスポット」のひとつの上に出現する。テチス海は閉じ続ける。アフリカ・プレートがユーラシア・プレートの下にしだいに沈み込み，ヨーロッパにおける高山の形成が加速される。とくにアルプス造山運動のあいだにアルプス山脈とピレネー山脈が出現する。

5900万年前　多くの場合飛ぶことができず，体高4mにも達する巨大な形態の鳥類（フォルスラコス類）が平原の支配者となり，カルノサウルス類（大型肉食恐竜）の絶滅によって空白にされた生態的地位を占領する。スズメ類（現生鳥類の半分以上を占める。ほとんどは小鳥）のような最初の現代的鳥類（飛ぶことができる新顎類）が出現する。哺乳類のあいだでは，小型の種以外に，角をもつ巨大な原始的種族も発達する。

5500万年前　始新世の気候の変化によって大気が急速に暖められる（10度以上）。この温室的気候が広大な熱帯林の出現を促し，ヨーロッパ，オーストラリア，北アメリカ，東アジアの褐炭層の形成を可能にする。哺乳類が驚くほどの飛躍を遂げる（齧歯類，コウモリ，偶蹄類，奇蹄類，ナマケモノ，霊長類など）のに対し，古い形態は消え去る傾向にある。

4400万年前　原始的な有蹄類が水陸両生の過渡的な形態と，次いで最初の真の海生哺乳類を誕生させ，後者からイルカとクジラ類のすべての代表例が生まれる。

3600万年前　哺乳類の多くの分枝が，気候が寒冷になり乾燥したせいで消滅する。低木地帯と半乾燥地的風景が出現する。

3400万年前　漸新世のあいだに，ほぼ恐竜の大きさに達する堂々とした哺乳類が発達するが，サイ，ラクダ，ウマ，ウサギ，ブタ，食肉類といった多くの現代的な形態も出現する。食肉類はネコ類（ネコ，マングース，ハイエナのような）とイヌ類（イヌ，クマ，オオカミ，カワウソ，アザラシのような）に分かれる。南極に向かって漂移し，暖流から遠く離れた南極大陸は極冠に覆われる。

3250万年前　南アメリカはパナマ地峡の水没によって，オーストラリアは南極大陸からの離脱によって，隣接する大陸から切り離される。

2500万年前　スズメ類の第二の急増がはじまる。

2400万年前　中新世のあいだに，アルプス，アンデス，ロッキー，そして世界最高の山脈であるヒマラヤが形成される。8000m以上の山頂をもつヒマラヤの形成は，インド亜大陸がユーラシア・プレートの下に潜り込んだことに由来する。

2200万年前　アジアから出発した草本植物は世界を征服する。アジアのステップ，アフリカのサヴァンナ，南アメリカのパンパスが出現し，やがて大陸表面の5分の1が草本に覆われる。反芻動物が世界のいたるところで急速に発展し，数百万の個体からなる群を形成する。その例にならい，すばやく持久力のある捕食者が広大な平原の生活に適応する。

1500万年前　サフル大陸（ニューギニア，オーストラリア，タスマニアを含む）を乗せたオーストラリア・プレートが北東に漂移し，東南アジアと衝突し，ニューギニアの山岳高原を形成する。

500万年前　鮮新世のあいだに，太陽活動の低下のせいで世界の気候は再びかなり寒冷化する。一連の氷期がとくに北半球で起こり，ときにはその表面の30%近くが厚さ数kmの氷の層に覆われる。北極から熱帯までの気候帯は分化し続ける。絶滅のいくつかの波が哺乳類の多くの原始的な種を襲う。

250万年前　3000万年孤立を続けたあと，主に有袋類が住んでいた南アメリカ大陸は，北の双生児と衝突し，種の「アメリカ間の大交換」を引き起こす。パナマ地峡が形成されたため大西洋の暖流の方向が変わり，気候の大変動が生じる。

‹ 新生代 ›
第四紀

‹ cénozoïque ›

氷期の新しい波が北ヨーロッパ，北アメリカ，北アジアなどを含む地表を襲う。

〈 新 生 代 〉

全地域が相貌を一変させる。生命は身を切るような寒さに屈する。すべての生命がだろうか。そうではない……

‹ cénozoïque ›

いくつかの種は脂肪と毛皮のおかげで，この寒く敵対する環境に適応することに成功する。

< 新　生　代 >

ケサイ，オオツノシカ，オオカミ，サーベルタイガーと同じく，ホラアナグマやホラアナライオンも寒さに抵抗する。

‹ cénozoïque ›

優柔不断な気候が長く続いたあと温暖になり……　　　　……極地域だけが氷のなかにとらわれている。

〈 新 生 代 〉

広大なサヴァンナが出現し……　　　……植物が点在し……　　　……獲物の蓄えは尽きることがない。

‹ cénozoïque ›

< 新 生 代 >

‹ cénozoïque ›

5.3 新生代　6550万年前から0万年前

5.3.2　第四紀　180万年前から0万年前

180万年前　更新世に世界は新しい氷期の波に襲われるが，それはおよそ20の増進期と後退期を含んでいる（すなわち寒い時期と暖かい時期が交互に訪れ，ほとんどの期間は10万年の寒冷期のあとに10万年の温暖期が続くというリズムをもっている）。最後の氷期のピークには，北アメリカやユーラシア北部の広大な地域と，アンデスやチベットの高山の連なりは厚さ数kmの氷の層に覆われる。

　地球の水全体の約5%は凍り，淡水の蓄えの90%は氷のなかにとらえられたので，海水準は100m近く低下する。

　更新世の動物相のなかで最も適応した者，寒さに抵抗した代表者は先史時代のゾウの仲間（マンモス，マストドン），有蹄類（ケサイ，オオツノシカ），そして捕食動物（ホラアナグマ，ホラアナライオン，サーベルタイガー）である。それらは堂々たる体軀をもち，毛皮と脂肪の層を発達させ，そのおかげで暖かさを保ち，進行する氷床のふもとに広がるツンドラで生き残ることが保証される。熱帯はもはや赤道の周囲の細長い帯でしかない。

1万年前　完新世のはじめに，新たな温暖期が氷を高山の氷河や極地域にまで後退させ，海水準は再び上昇する。大型哺乳類の大部分は，ヒト科生物がしかける狩猟によって大量殺戮されたこともあり，この新たな気候変化を生き延びることができずに消滅する。

0万年前　新たな時代，われわれの時代の始まり……

〈 新 生 代 〉

人 類 代

　新たな時代，「人間の時代」がはじまる。
　人間は本書で扱った二つの最後の時期，すなわち第三紀の終わりの鮮新世と，第四紀全体のあいだにすでに最初の歩みを踏みだし，アウストラロピテクスやホモ・エレクトゥスのような原始人類を出現させた。
　しかし著者は『ベータ…文明』と題されたこのシリーズの第2部において専念するために，『アルファ…方向』ではヒト科の進化には触れないことにした。『ベータ…文明』は500万年におよぶ，人類とその文明のこんにちまでの進化をじっくり検討するであろう。
　この3部作の最後の巻『ガンマ…ヴィジョン』は，将来に起こりうる進化とその視覚化に力を注ぐことになる。

‹ annexes ›

後記／序文

「結局のところいかにしてすべては始まったのか，いかにしてすべては終わるのかという二つの疑問だけが人間の気がかりのたねである」（スティーヴン・ホーキング）

　明らかに，これらの疑問に対してはひとつの答えに近づくことしかできない。第二の疑問に関しては，いずれ明白になるだろう（無謀な思弁や流行する分析に影響されるままにならないなら）と考えるか，あるいは循環的モデルや，少なくとも未来にとってありそうなモデル，過去の出来事から演繹される因果的連鎖や法則を認めるかであろう。第一の疑問に関しては，さまざまな分野の研究とそれが提供するモデルを結合し，天文学，物理学，化学，生物学，古生物学，考古学などのますます増大する知識の状態を組み合わせることができる。

　われわれの背後を見てみよう。21世紀の科学と技術の飛躍は，人々のあいだに過去に対する関心の高まりを引き起こした。はじめて，驚くべき掘りだし物を公衆に提示することだけに満足せず，天地創造やノアの洪水の観念に頼らずにそれを説明する試みもなされた。世界中のいたるところで，発掘によって巨大な骨，石化した不思議な形態，奇妙で巨大な痕跡，全体が石炭に変化した森林などが明るみに出された。これ以後「化石」と呼ばれるようになったこれらの物体を提示する，さまざまな方法がすぐに発達した。まずはそのころ流行した万国博覧会で展示され，次に移動展覧会や新たにつくられた博物館に集められた。こんにちでも専門家チームは地球の隅々を綿密に調べ，南極大陸の氷を試掘し，すべての鉱山，すべての建設現場で新しい戦利品を探し求める。このテーマについてのすべての公刊物，すなわち本，雑誌，CD-ROM，コンピューター・アニメーション，インターネット・フォーラム，ドキュメンタリー，映画などの全貌を得ることはほとんど不可能になっている。

　遅くとも6，7歳のころ，わたしもこの太古の時代に関心をもち始めた。もともとわたしには（『ジュラシック・パーク』のずっと前だったとしても），同じ年頃の多くの子供が恐竜に対して抱くのと同様の情熱があった。両親はわたしを古生物の展覧会に連れて行き，わたしたちはベルリンの自然史博物館の前で何時間も列を作り，拡大し続けるバウツェン近くのクラインヴェルカ恐竜公園を見物した（1970年代の末に，ある熱烈な愛好家が庭園の片隅に鉄筋コンクリートで恐竜を建造し始めた。こんにちではコレクションが市立公園全体を占領し，ドイツにおけるこのジャンルの最も重要なコレクションと見なされている）。しかもわたしの生まれた環境と地域が，この関心の発展において無視できない役割を演じた。わたしは旧東ドイツ，オーバーラウジッツ地方のヴァイスヴァッサーで育ち，ごく幼い頃から，そこではすべてのものが何百回も変化させられたこと，その変化は現在も続いていることを自覚していた。他方で，この地域全体は氷河の相次ぐ通過によってえぐられ，どれほど小さな丘も氷河の活動を思い起こさせた。氷はわれわれにいくつかの記念品を残してもいた。迷子石と呼ばれる，スカンディナヴィア全体からやってきた滑らかな岩石の巨大な塊があった。そのうえ，われわれの地域の地下には広大な褐炭の層が眠っていた。巨大な掘削機が原初の森の痕跡のなかを掘り，飾り気のないいくつかの村と広大な荒野を荒廃させ，そのあとに索漠とした地球外の風景を残していく。わたし自身もボクスベルクの発電所（いまでも誇らしげに断言されているように，褐炭を燃料とするヨーロッパ最大の発電所）で実習をしていたとき，「黒い金」というこの第三紀の遺産を，怪物じみた煤の雲とエネルギーに変換することにありったけの情熱を燃やしていた。

　父に励まされて，絵を描くことはすでにずっと以前から，わたしのお気に入りの活動の一部となっていた。そこでわたしは突飛な形をした，どちらかといえば吐き気を催すようなにおいのプラスチックの恐竜（ポーランド製。それほどにおいの強くない香港製のものは希少品だった）で遊ぶことに満足せず，ごく自然にこの原始生物の絵を描いてもいた。そうするために，わたしはむろん手に入るすべての図像を細かく分析した——もっとも，本書のためにも同様のことを行なったのだが。やがてわたしは過去の時代についての驚くほど生き生きとしたヴィジョンが現在でも比類のない，チェコの画家ズデニェク・ブリアンを発見した。わたしは何ダースもの古生物の出版物のなかで見た彼の絵を，何度も模写して内在化し始めた（師がわたしを許し，『アルファ』のなかのいくつかのテーマにとり，彼の作品がしばしば着想の唯一の源泉であったという事実を，彼の作品への賛辞と見なしてくださるように）。

　思春期のころ，このテーマに対するわたしの熱狂は少し減少した。それでもときにはノスタルジーを感じて，図書

付録

　館の棚からブリアンの本を取りだすことも相変わらずあった（当時その本を自分のものにすることは不可能だった。よい状態のそれを探すことができるようになったのは，インターネット時代が到来してからであった）。しかしこの禁欲はつかの間のものでしかなかった。世界と生命の起源の問題は，こんにちわたしの心を奪うすべてのことにとってあまりにも本質的かつ重要である。宗教は答えを与えてくれなかったし，世界についての秘教的な概念もそうであった。それに加えて，1990年代から人々の精神のなかにますます巣食うようになった，われわれの生物圏の保護という問題が存在した。注意深く検討するなら，この問題はわれわれをかなり直接に，地球が経験した過去の激変のシナリオへ，途方もない気候の変化へ，氷期へ，大量絶滅の波へと連れ戻すだろう。このような出来事は数百万年にわたって繰り広げられたのだが，現在のわれわれ人間はすべての事柄がもう少し速く進行するかもしれないということを，自然に対し示すのにもっと恵まれた位置にいる。

　われわれがどこから来て，どこへ行くのかという問題は人々の情熱をかきたてる。進化論の支持者と創造論者（神による創造を信じる者たち）とを分かつ溝は，現代の発展を目の前にしてより深くなっている——東洋でも西洋でもファンダメンタリズムの再来，価値の体系の固有の急進化が問題となっている。すでにアメリカのいくつかの学校では，生物学の授業が聖書の命題と矛盾することのないよう注意が払われている。同様にある種の人々は，ドイツの学校教育からダーウィンの理論が追放されることを願っている。

　それでもダーウィンの発見から発展した知識はきわめて重要なので，それらは進化全体の普遍的モデルと見なされなければならない。ここでわたしは「最適者生存の法則」の悪しき解釈に起因する，ときに人種差別主義にまで進む奇妙な暴走のことは語らない。進化のなかの「進歩」の観念が必ずしも必要なのではなく，むしろいまあるものの絶えざる発展の観念が重要なのである。というのも以前だされた解答への回帰や，螺旋的あるいは循環的発展も完全に競争力をもちうるからである。変異，突然変異，共生，結合，収斂や適応は，生物学においてだけでなく，技術的進化に関しても，また社会的関係，言語体系，建築や音楽といったさまざまな領域においても有効である。そして必然的に，この法則を否定する人々の領域——宗教，その世界観，その教義，その議論——においても価値がある。

　わたしは『アルファ』によって，ビッグバンと呼ばれる始点から出発しながら，われわれが知る宇宙の誕生を想像するために，われわれが所有するすべての視覚表現を初めて収集しようと試みた。かつて非識字者たちのために編まれた「絵による聖書」に似ているが，本書は科学的基盤に立脚した，いかなる告白も強制されない，読むことのできる人々に向けたものである。だからといって神的な表現や宗教的な象徴が，本書にまったく登場しないというわけではない。逆にわたしはしばしば天地創造や原初のさまざまな力，伝説の人物や楽園に関する昔の表現を進んで援用した。というのもそれらはときに驚くべき流儀で（非常に曖昧なままであっても），たとえばハッブル宇宙望遠鏡の画像やDNA解析のような最近の科学的発見のおかげで，こんにちその秘密が突きとめられているある種の過程を予感しているからである。他のいくつかの挿絵は逆にその素朴さが感動的であり，非常識なほど空想的なので，素粒子の流れのような仮説的運動の少々無味乾燥な絵のあいだに，それらを挿入するという誘惑に抵抗することができなかった。たとえそれらの機能が説明することではなく，むしろそこで生起している事象との対照を際立たせることだったとしても。

　したがっていくつかの細部を別にすれば，本書の絵を個人的な創作と見なさないでいただきたい。このような3部作の枠組みのなかで，わたしの想像力から発したような過去を，紙の上に定着しようと望むことはさほど興味深いこととは思われない。反対に当初からわたしが従ってきた方針は，できるだけ多くの図像的源泉を収集し，それらをページのなかで結合するということであった。『アルファ』によって，わたしは人類の歴史3万年の図像的創造から借用したパノプティコン（一望監視施設）を——クロマニョン人の最初の洞窟壁画から3D映像までの表現の要約をつくりたいと考えた。わたしは明らかに，古代のモザイクの創作者からルネサンスの画家を経て，ここ数十年のパレオアートの最も有名な代表者たち，およびテーマや物語が適合したときの漫画の作者まで，多くの偉大な絵師たちを統合しようとしていた。したがってこのような観点からすると，『アルファ』は資料収集の作品と見なせるかもしれない。というのもわたしは進化の過程そのものだけでなく，世界の表現と思想の進化や，すべてのものの起源と世界のイメージがどのように変化したかも提示しているからである。正当性はそれぞれの時代に限定されている，さきほど言及した宗教的引用のほかに，わたしはさまざまな時代の科学的挿絵の例も加えようとした——そのうちのいくつかは初

‹ annexes ›

歩的な知識の状態に対応しており，ずっと以前に時代遅れとされてしまったが（288ページ上のイグアノドンのように），他のものはBBCの魅力的なコンピューター・アニメーションのように現在でも意義を保っている。

　わたしは常に時間を熟考することに関心を抱いてきた。第4次元のこの触れることのできない題材は，140億年以上を350ページ足らずで描くことは冗談のように見えるにせよ（およそ2000の絵があるので，平均すればひとつの絵が700万年に相当する），漫画のような連続画にもとづいた媒体によってしかうまく接近できないだろう。わたしの心につきまとい，われわれ人間には常に「奇蹟」のように思われるのは，とくに生命の出現という大きな謎なので，わたしは絵によってそれに近づこうとすることに本書のかなりの部分を捧げた。本書の制作と並行して，わたしにはわれわれの子供たちの進化を追跡する機会があった──少々不鮮明な初期の超音波検査画像から，5分間で客間を戦場に変えてしまうとはいえ，彼らの最初の絵を喜んで描くこともすでにできる4歳半のこんにちまでの進化を。しかし『アルファ』のなかに常に存在する観念は，何ごとも決して終わらず，何ごとも完全ではなく，すべてが，この物語さえも変化するというものである。この物語はたえず修正され，4年半前にわたしが作業を始めたときからだけでも，すでに世界についてより多くのことが知られている。ずっと以前から多くのことが確証され，多くのことが放棄されてもいるが，わたしはそれをまれにしか考慮に入れられなかった。3部作のこの最初の巻の新版をいつか制作することになるなら，わたしは確実にいくつかの図版を追加するか修正するだろう。そしてもしかしたら今後他の漫画家たちが，「すべての時代についてのより長い物語」を語ろうとするかもしれない──実際にそうするだけの価値はあるとわたしは考えている。

<div style="text-align:right">

2008年10月

イェンス・ハルダー

</div>

〈 付 録 〉

著 者
── イェンス・ハルダー（1970年にドイツ民主共和国のヴァイスヴァッサーで生まれる）は1996年から2003年までベルリン・ヴァイセンゼー美術学校でグラフィックアートを学んだ。

── 帰化した都市のベルリンで数年前からイラストレーターや漫画の作者として仕事をしている。いくつかの画集と物語を発表し，さまざまな国際的な賞を獲得している（エルランゲン漫画サロンにおける最優秀ドイツ漫画マックス＆モリッツ賞，2004，2010。エー・オー・プラウエン協会奨励賞，2007。アングレーム国際漫画祭における大胆賞，2010。ハンス・マイト賞，2011）。

── 彼の作品はドイツのいくつかの都市と，エクス，バーゼル，ベロオリゾンテ，クリティーバ，ジュネーヴ，エルサレム，リスボン，リュセルヌ，ノヴォシビルスク，オスロ，パリ，ポルトアレグレ，テルアヴィヴ，チューリッヒなどで展示された。

── 彼はさまざまな漫画雑誌（Mogamobo, *Nosotros somos los muertos*, Panelなど）とアンソロジー（*Alltagsspionage*, Monogatari 2001; *Warburger*, Stripburger 2003; *Operation Läckerli*, Monogatari 2004: *CARGO-comicreportagen israel-deutschland*, Avant-verlag 2005; *Beasts Vol. II*, Fantagraphics 2008; *Gods & Monsters*, NoBrow 2009など）に作品を発表している。

ここ数年に刊行されたイェンス・ハルダーの作品。
LEVIATHAN（ドイツ語・フランス語・英語・日本語4か国語版 Editions de l'An 2, 2003）
La Cité de Dieu（フランス語版　Editions de l'An 2, 2006）
MIKROmakro（ドイツ語・フランス語2か国語版　vfmk-Verlag für moderne Kunst Nürnberg, 2007）
ALPHA...*directions*（フランス語版　Actes Sud-L'An 2, 2009, ドイツ語版　Carlsen Comics, 2010）
BETA...*civilisations*（フランス語版　Actes Sud-L'An 2, 2014, ドイツ語版　Carlsen Comics, 2014）

‹ annexes ›

< 付録 >

左ページ：
ステゴサウルス対アロサウルス（ズデニェク・ブリアンにもとづく）／節足動物コレクションⅠ＋Ⅱ。

右ページ：
キンカジュー／モア／白亜紀の研究（ズデニェク・ブリアンにもとづく）／オセロット／マストドン対マンモス。
下絵とデッサン，1979-1981年。

‹ annexes ›

『アルファ』のストーリーボード。作業の最初の段階（2004-2007年）の下絵。

付　録

‹ annexes ›

< 付 録 >

左ページ：『アルファ』のオリジナル・ページの複製（A3の紙に鉛筆と墨で描いた）。

‹ annexes ›

地質年代

隠生累代
<small>いんせいるいだい</small>
46億年前から5億4200万年前

冥王代
46億年前から39億年前

太古代
39億年前から25億年前

原生代
25億年前から5億4200万年前

顕生累代
<small>けんせいるいだい</small>
5億4200万年前から0万年前

古生代

カンブリア紀	オルドヴィス紀	シルル紀
5億4200万年前	4億8830万年前	4億4370万年前

デヴォン紀	石炭紀	ペルム紀
4億1600万年前	3億5920万年前	2億9900万年前

中生代

三畳紀	ジュラ紀	白亜紀
2億5100万年前	1億9960万年前	1億4550万年前

新生代

第三紀

暁新世	始新世	漸新世	中新世	鮮新世
<small>ぎょうしんせい</small>	<small>ししんせい</small>	<small>ぜんしんせい</small>	<small>ちゅうしんせい</small>	<small>せんしんせい</small>
6550万年前	5580万年前	3990万年前	2303万年前	533万年前

第四紀

更新世	完新世
<small>こうしんせい</small>	<small>かんしんせい</small>
180万年前	1万1500年前

〈 付　録 〉

6日間での世界の創造。
リヨンで刊行された聖書（16世紀）より。

‹ annexes ›

‹ 付 録 ›

Systematischer Stammbaum des Menschen.

Anthropogenie VI.Aufl. Taf. XX.

E. Haeckel del.　　　　　　　　　　　　　　Lith.Anst.v.A.Giltsch Jena

左ページ：順に全生物，動物，脊椎動物の系統樹。
エルンスト・ヘッケル『有機体の一般形態学』（1866年）より。

右ページ；人類の体系的な系統樹。
エルンスト・ヘッケル『人類発達史』（1874年）より。

« annexes »

< 付録 >

動物界の進化の概観。
1960年代の百科事典より。

‹ annexes ›

ベンジャミン・ウォーターハウス・ホーキンズ（1854年）

ニーヴ・パーカー（1960年頃）

ベンジャミン・ウォーターハウス・ホーキンズ（1859年）

はじめは四肢で…
ロバート・オーウェンの指示にもとづき，ロンドンの「クリスタル・パレス」に設置された実物大の彫刻と，その彫刻にもとづくデッサン。

次には後肢で立って。
鳥脚類の骨盤は鳥類のそれに似ているという，解剖学の知識の状態に対応した科学的情報にもとづいて制作された絵。

恐竜（2010年）

次にこんにちでは再び四肢で立つ。
現在の考えに対応した立体模型。この動物たちは尾で均衡をとりながら，主として四肢で移動する（ソフトウェアPoser 5-8を使用／DAZ Studio）。

古生物学的表現の進化の諸段階。イグアノドン（1822年に発見された）の例。
（288ページも参照のこと。上段の右はギデオン・マンテルによる古いデッサン。上段の左は古生物学者たちを「クリスタル・パレス」での晩餐に招くために，ホーキンズによって制作された実物大の模型）

〈 付 録 〉

方向　adams, audubon, auster, blu, borges, bruno, comenius, couché, darwin, dawkins, debeurme, dennett, diamond, ford, forster, eco, hawking, hooke, larousse, lautréamont, lem, mare, margulis, mattotti, miyazaki, morris, murakami, musturi, ovid, pettibon, poe, pynchon, rabelais, schwägerl, scape, seba, shubin, strugatzki, verne, ware, wolverton

音楽　bell, clark, ellison, fsol, funk, james, jelinec, jenkinson, jenssen, jerome, kozalla, lippok, oceanclub, patterson, peel, plaid, sandison, vibert, warp

感謝　ACBD, AS-BD, BBC, BD-FIL, CNBDI, CRS, CS14, CSV, FIBD, FIQ, GBS, GEO, HMS, KHB, MPG, NAFÖG, NSLM, SMNK, VFMK, VG B+K, ZLB

出典　de la beche, bosch, botticelli, brueghel, burian, busch, cranach, disney, doré, dürer, ernst, flammarion, furtmayr, giacometti, van gogh, goya, grandville, grünewald, gurche, haeckel, hallett, hawkins, henderson, hergé, hokusai, holbein, lichtenstein, magnus, magritte, mccay, mcguire, merian, michelangelo, pisanello, raffael, sibbick, tanaka, trondheim, da vinci, wegener, woodring etc.

挨拶　alex, andra, andreas, anna, anne, auge, augusto, ayelet, barbara, bastién, benjamin, cecile, chiqui, christian, claudia, conny, constanze, cuno, cristo, detlef, diez, dino, dirk, einat, emmanuel, evelyn, ferdinand, fernanda, fil, frederik, gabi, grit, guido, gianco, gottfried, gregor, hannes, hans, henni, hennink, henrik, henry, hülia, iliana, jan, joachim, john, josé, josepha, kairam, karsten, katharina, kati, klaus, konrad, lara, lars, laureline, leó, leoni, liane, line, lothar, lucie, manuele, marc, marcel, mario, marion, martin, matthias, mawil, max, micha, mimi, myriam, nanne, naomi, niki, norbert, okko, opp, pascal, paul, pedro, peter, pia, pierre, ralf, reinhard, reinhold, roberto, roland, sabine, schyda, sebastian, sébastien, serge, stephan, stephen, stéphanie, thaís, thierry, thomas, tim, tine, titus, tom, tomi, uli, valis, verena, vicki, viola, xoan

ここに書き忘れたすべての人々。

およびわたしの家族，とくに愛するフランツィスカ，わたしたちの子供シャルロッテとマッテオに。

‹ annexes ›

図像の出典

『アウロラ・コンスルゲンス』p.77，2段右 『アルデア』p.243上左 アルバーニ（フランチェスコ）p.226上左 ヴェーゲナー（アルフレート）p.280，2段 ヴェヒトリン（ヨハン）p.174中 ウッドリング（ジム）p.180，2段右 エウフロニオス p.175上右 エルジェ p.209下中 エルンスト（マックス）p.179上／226，2段 オックスフォード・サイエンティフィック・フィルム会社 p.251下左と3段／274上左と上右／288下右 オラウス・マグヌス p.211上／287，2段 オリヴァー（ケン）p.242，3段左／290，2段左 カー（カレン）p.291上／332下 カエターニ（ミケランジェロ）p.127上中 カーク（スティーヴ）p.258，3段／259上右／290下左 ガーチ（ジョン）p.172下／213／240上／270上右と中／276，2段と下右 カラッチ（アンニーバレ）p.175上左 カロルスフェルト（シュノル・フォン）p.90，2段左 キルヒャー（アタナシウス）p.79中 クエルチャ（ブリアーモ・デッラ）p.127上中と右 クラナッハ（ルーカス）（父）p.305上左 グランヴィル p.65中 グリューネヴァルト（マティアス）p.258上左 グロスマン（ゲルハルト）p.287，2段左 ケプラー（ヨハネス）p.35上左 ゴッホ（フィンセント・ファン）p.285中 ゴヤ（フランシスコ・デ）p.175中 コンスタンティノフ（ヴラド）p.289下右 サイエンス・フォトライブラリー p.291下右 シェーデル（ハルトマン）p.103上 シビック（ジョン）p.175下／209上と中左／212下／217上右／229下／235／238上右／242上右／243，3段／253中／255上／256下左／266上／271上右／272，3段左／276上右／278下／279上／288，2段／300中右／309下左／325上 ジャコメッティ p.179中右 シャルメ（ジャン＝ルー）p.261上左 シンプソン（トム）p.260上 スホーテン（フランス・ファン）p.125上 セラリウス（アンドレアス）p.57中左 ソバック（ヤン）p.320下 ダーウィン（チャールズ）p.308，2段右 田中政志 p.257上 チャオ・チュアン／シン・リーダ p.274上中 テニエル（ジョン）p.308，2段左 デュモント（ジョン・S）p.321下右 デューラー（アルブレヒト）p.277上中／310下左 デ・ラ・ビーチ（ヘンリー・トマス）p.271下 『天球論』p.156，3段中 トム・リング（ルトガー）（子）p.319下中 ドレ（ギュスターヴ）p.252下右／297上右／304下左 トロンダイム（ルイス）p.239下 ナイト（チャールズ・R）p.309，2段右 ニューマン（エドワード）p.254下右 ニューマン（コリン）p.229，3段／231，2段 ノーボスチ・フォトライブラリー p.332，2段右 バイユーのタペストリー p.67下右 ハイルマン（ゲルハルト）p.289上右 バークス（カール）p.198下／288下 ハレット（マーク）p.266下 ハント（ウィリアム・ホルマン）p.320，3段中 ピサネロ（アントニオ）p.243下右 ヒルデガルト・フォン・ビンゲン p.80中 フォンテーヌブロー派 p.309下右 ブッシュ（ヴィルヘルム）p.329，2段右／332，2段左 ブリ（テオドール・ド）p.175，2段 ブリアン（ズデニェク）p.134上右／165／168-169／185上／187下／190下／193／194下／195上左と中左／196下／199上／202下／210下／211中／214上左／219／221下左／222-223／224上／225下右／229，2段／230下／231下／238下／239上右／240下右／241中と下／243下／247／248下左／249下中／250下左／251下右／253上と下／256上左／258，2段右と下／259上左と4段右／263／265，3段／268-269／272，3段右／275／283／288，3段／289，3段左／292／294下右／296上／297中／303／306中／307／309上右／310，2段左と4段3つ目／311，2段と下／316-317／318上／321上右と下右／322上左と下右／323／327／330下／331，2段と3段と下／334および表紙におけるいくつかの引用 フリードリヒ（カスパー・ダーヴィト）p.285，2段左 ブリューゲル（ピーテル）（父）p.230中右 フルトマイヤー（ベルトルト）p.148上右 ヘッケル（エルンスト）p.176下／180上中と2段左および中 ベルゲン（デヴィッド）p.289下左 ヘンダーソン（ダグ）p.251上 ボウテル（ロビン）p.216上 ホーキンズ（ベンジャミン・ウォーターハウス）p.261上右と3段目左／288上左 北斎 p.82下右／92下／99上右 ボス（ヒエロニムス）p.172, 2段／179上右と2段左／227上右 ボッティチェッリ（サンドロ）p.150，2段／176上左 ホデル（エルンスト）（弟）p.328下／329下 ポール（グレゴリー・S）p.270下右／294上／300, 3段左 ホルバイン（ハンス）（父）p.261下 マイスター・ベルトラム p.178下 マイヤー（ミヒャエル）p.261中右 マクガイア（リチャード）p.290，2段中 マグリット（ルネ）p.76中左 マターンズ（ジェイ）p.321上右と2段左 マッケイ（ウィンザー）p.265，3段右 マルティン（ラウール）p.267下 マンセル／タイム・インコーポレイテッド p.299，2段左 マンテル（ギデオン）p.288上右 ミケランジェロ p.76上左 メーリアン（マリア・ジビラ）p.237下／286下 ラートゲーバー（トーマス）p.294中 ラファエロ p.226上右 ランブール兄弟 p.320，3段左 リキテンスタイン（ロイ）p.298下右 レオナルド・ダ・ヴィンチ p.90，3段右／92上左 ロマーノ（ジュリオ）p.232上

および次にあげる映画の場面：

『月世界旅行』p.85下右 『バグズ・ライフ』p.237，4段中 『ファンタジア』p.265下左 『ゴジラ』p.295，2段 『ジュラシック・パーク』p.264，2段／290，2段左 『白鯨』p.315下左 および BBC 製作のドキュメンタリー3部作『ウォーキング with ビースト』p.297下左／306上／309，3段左／310，2段右／314上右と中左／315上左と下右／330上中と上右／331上 『ウォーキング with ダイナソー』p.250上と2段／252，2段／255中左と下／257，3段と下／259，2段／270下左／272下左と右／273下／278上／289上右／290下右／291中と下右／295上と3段と下／297上左と下右 『ウォーキング with モンスター』p.190上／208中と下／209中右／226，4段中／227下左と右／228上左／240中／241上／242上左と2段／248下右／249上左と右

いくつかの絵は次のものから着想を得ている。アボリジニー，イヌイット，ケルト，スラヴの伝説，アフリカ，インド，ポリネシア，スカンディナヴィアの神話，エジプト，ゲルマン，ギリシア・ローマ，ペルシアの神々，仏教，キリスト教，道教，ヒンズー教，イスラーム，ユダヤ教，神道および石器時代の狩猟文化など。

‹ 付 録 ›

著者は本書でその作品を利用し，描き直したすべてのイラストレーター，画家，漫画家，写真家，映画人，彫刻家に感謝する。

ジョン・シビックのイラストから借用したテーマは主として次の著作に由来する。
David E. Fastovsky & David Weishampel, *The Evolution and Extinction of the Dinosaurs*, Cambridge University Press, 1996
Peter Wellnhofer, *Illustrated Encyclopedia of Pterosaurs*, Crescent, 1991

彼が扱った多くのテーマを再び採りあげることを許可してくれた，チェコの画家ズデニェク・ブリアンの権利所有者にとくに感謝する。ブリアンに着想を得た『アルファ…方向』の絵は，主として「古生代」「中生代」「新生代」の各章に見られ，次の著作に由来する。
Josef Augusta & Zdeněk Burian, *Pravěká zvířata*（『太古の動物』），Artia, Praha, 1960
Zdeněk V. Špinar & Zdeněk Burian, *Život v pravěku*（『太古の生命』），Werner Dausien, Hanau / Artia, Praha, 1973
Bořivoj Záruba & Zdeněk Burian, *Svět vyhynulých zvířat*（『絶滅動物の世界』），Artia, Praha, 1982
Vratislav Mazák & Zdeněk Burian, *Pračlověk a jeho předkové*（『原人とその祖先』），Artia, Praha, 1983

‹ annexes ›

純粋主義者の方々へ
事実の点でも絵の点でも，本書でわたしは何も発明していない。人間の歴史を図像化するために，わたしは化石の画像だけでなく，3万年におよぶ文明の歴史のあいだに，人類の何人かの代表者が制作した膨大な視覚的遺産も使用した──新石器時代の洞窟壁画からギリシアのモザイクまで，中世の祭壇画から近代のダゲレオタイプまで，さらに宇宙望遠鏡によって撮られた写真や3Dのデジタル表現までを利用した。

信仰の厚い方々へ
この3部作は宣教の意図をまったくもっていない──たとえ無神論的世界観が必然的にページのなかに透けて見えるとしても，わたしは誰も改宗させようとは思っていない。これらすべての出来事について科学にもとづいた考えを共有する読者や，いずれにせよ信仰と進化論とを和解させることのできる読者に語りかける方が，わたしには興味深いと思われる。それでも新しい知識が獲得されるたびに，科学の次元においてだけでなく，神学の次元においても新しい疑問は登場するので，そのことはわれわれがわれわれ自身についてもつイメージに深い影響をおよぼすのである。

< 付　録 >

マンガ・ファンの方々へ
もしあなたが習慣から『アルファ』をこのページによって開いたなら，ここから前へ読み進めていただきたい。そうすればあなたは本書に表現されているすべての過程と発展を，斬新奇抜な方法で，通常は視覚的に理解することが不可能な脈絡で検分できるだろう。各ページを右から左へだけでなく，下から上へと読むことにも留意するならばだが。

科学者の方々へ
本書は読者を宇宙と生命の進化のある種のヴィジョンに改宗させようとするものではない。ここで重要なのは世界の生成についての可能な表現であり，したがって本書では現在形が使用されている。きわめて多様な理論と知識がこれらのページの仕上げをつかさどり，それらは最近の研究の成果に常に対応しているわけではない。わたしは主観的観点から，それら多様な理論と知識を，その可能性と強力な視覚的潜在力にもとづいて選択したのである。

【訳者後記】
　著者イェンス・ハルダーは宇宙・地球・生命の歴史を想像力豊かに描く壮大な3部作を制作中であり，本書はその第1部 *Alpha...directions* の日本語版である。この *Alpha* は2009年にフランスのActes Sud社よりフランス語初版が出版され，翌2010年にはハルダーの母国でドイツ語版が刊行された。また2015年には中国語版と英語版（ドイツ語版にもとづいていると思われる）が相次いで発行され，読者層は世界中に広がっている。現在のところ，3部作のうち第2部 *Beta...civilisations* の第1巻（ヒト科生物の誕生からイエスの出現までを扱う）が2014年に刊行されている。紀元後から現在までの世界を展望する *Beta* の第2巻，および未来の進化を描くとされる第3部 *Gamma...visions* の完成を心から待望したい。なおこの日本語版は2014年に出版されたフランス語改訂版（絵には変更はないが，キャプションは若干修正され，ドイツ語版にならって「図像の出典」が追加されている）をもとにしてフランス語から翻訳した（ドイツ語版と英語版も参照している）。

【訳者紹介】
菅谷暁
（すがや さとる）

1947年生まれ。科学史研究者。東京都立大学大学院人文科学研究科博士課程退学。
訳書：コイレ『ガリレオ研究』（法政大学出版局，1988），ゴオー『地質学の歴史』（みすず書房，1997），
ラドウィック『太古の光景』（新評論，2009）など。

アルファ
2016年5月23日初版第1刷発行

著者
イェンス・ハルダー
訳者
菅谷暁
発行者
佐藤今朝夫
発行所
国書刊行会
〒174-0056　東京都板橋区志村1-13-15
電話 03-5970-7421　ファクシミリ 03-5970-7427
URL：http://www.kokusho.co.jp　E-mail：sales@kokusho.co.jp

組版........山田英春
印刷所........株式会社シーフォース
製本所........株式会社ブックアート

ISBN978-4-336-06003-7 C0071

ALPHA...directions
Jens Harder

© Actes Sud, 2009
Japanese translation right arranged with Edition Actes Sud, S.A., France through Motovun Co.Ltd.,Tokyo.